THE PRINCIPLES OF UNCERTAINTY

Maira Kalman

THE PENGUIN PRESS

New York

2007

THE PENGUIN PRESS
Published by the Penguin Group
Penguin Group (USA) Inc., 375 Hudson Street, New York, New York 10014, U.S.A.
Penguin Group (Canada), 90 Eglinton Avenue East, Suite 700, Toronto, Ontario, Canada M4P 2Y3
(a division of Pearson Penguin Canada Inc.)
Penguin Books Ltd, 80 Strand, London WC2R 0RL, England
Penguin Ireland, 25 St. Stephen's Green, Dublin 2, Ireland (a division of Penguin Books Ltd)
Penguin Books Australia Ltd, 250 Camberwell Road, Camberwell, Victoria 3124, Australia (a division
of Pearson Australia Group Pty Ltd)
Penguin Books India Pvt Ltd, 11 Community Centre, Panchsheel Park, New Delhi – 110 017, India
Penguin Group (NZ), 67 Apollo Drive, Rosedale, North Shore 0632, New Zealand
(a division of Pearson New Zealand Ltd)
Penguin Books (South Africa) (Pty) Ltd, 24 Sturdee Avenue, Rosebank,
Johannesburg 2196, South Africa

Penguin Books Ltd, Registered Offices:
80 Strand, London WC2R 0RL, England

First published in 2007 by The Penguin Press,
a member of Penguin Group (USA) Inc.

1 2 3 4 5 6 7 8 9 10

Copyright © Maira Kalman, 2007
All rights reserved

Most of the contents of this book first appeared online as the author's column
"The Principles of Uncertainty" on TimesSelect (The New York Times).

Goethe translation (p. 126–131) by Stuart Atkins

LIBRARY OF CONGRESS CATALOGING IN PUBLICATION DATA AVAILABLE

ISBN: 978–1–59420–134–9

Printed in the United States of America
Designed by Buchanan-Smith

To my beautiful mother Sara

Table of Contents

MAY 3, 2006

●

Some sun. Overcast skies and a few
showers will prevail.

How can I tell you everything that is in my heart. Impossible to begin. Enough. No. Begin.

With the hapless dodo. galumphing innocently around Mauritius sporting a ridiculous plume. Then — out of the blue — man arrives with a hankering for a dodo sandwich and

POOF!

By 1681 — Extinct. No more dodo.

As the Last Dodo was running for its life, Spinoza was trying to figure out a Rational explanation for everything! (You too?) Sporting some handsome curls (which look somewhat frivolous for someone so monumental) he searched for Eudaimonia (which is not a kind of Amonia) but the state of Happiness we are all looking for though when I used to tell my sublime mother I wanted to be happy

She would say "What is Happiness?" Really. But then he too breathed his last (with loved ones around him?) and POOF. No more Spinoza. He was extinct. We don't even have a stuffed Spinoza.

WE do HAVE a STuFFed PAVLOV'S DOG. I visited HIM in the MuSEUM oF HYGIENE in St. PETERSBURG (RUSSIA). HE is Dusty and SCRuFFy with an OMINOUS ELECTRICAL BoX oN his RuMP.

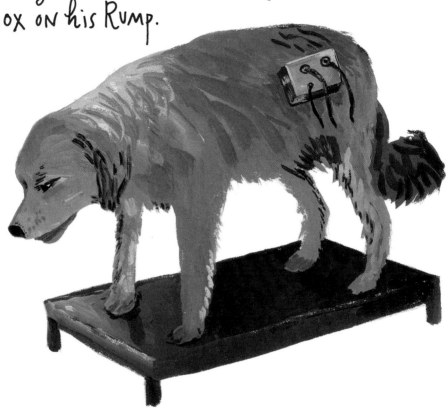

HE is guARded By INCREDIBLy NaSTy museum guARd WOMEN, in what was ONCE a Splendid MANSION where, I imagine, Relatives oF Catherine the GReat gathered FoR MUSICaLes and BLINi. But then the Bolsheviks aRRived and POOF - goodbye MusicaLes, Goodbye BLINi.

It must have been a very, very dark day when The Bolsheviks arrived. Maybe amongst themselves they had a few good laughs, but Stalin was a paranoid man (even more than my father) and decided his top people had to be Extinctified. Goodbye Bolsheviks.

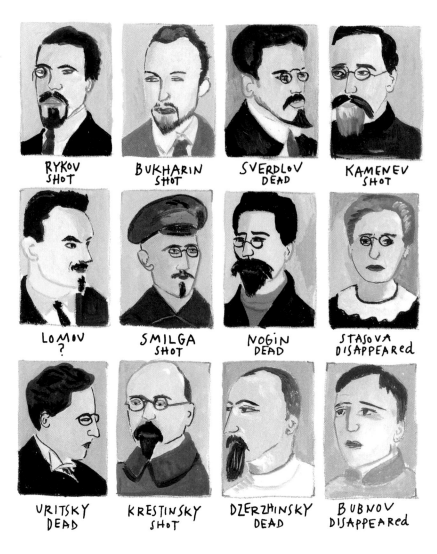

RYKOV
SHOT

BUKHARIN
SHOT

SVERDLOV
DEAD

KAMENEV
SHOT

LOMOV
?

SMILGA
SHOT

NOGIN
DEAD

STASOVA
DISAPPEARED

URITSKY
DEAD

KRESTINSKY
SHOT

DZERZHINSKY
DEAD

BUBNOV
DISAPPEARED

I left out Zinoviev, Trotsky, Kollontai, Sokolnikov, Shaumyan, Berzin, Muranov, Artem, Miliutin, Joffe.

TO NAME A FEW.

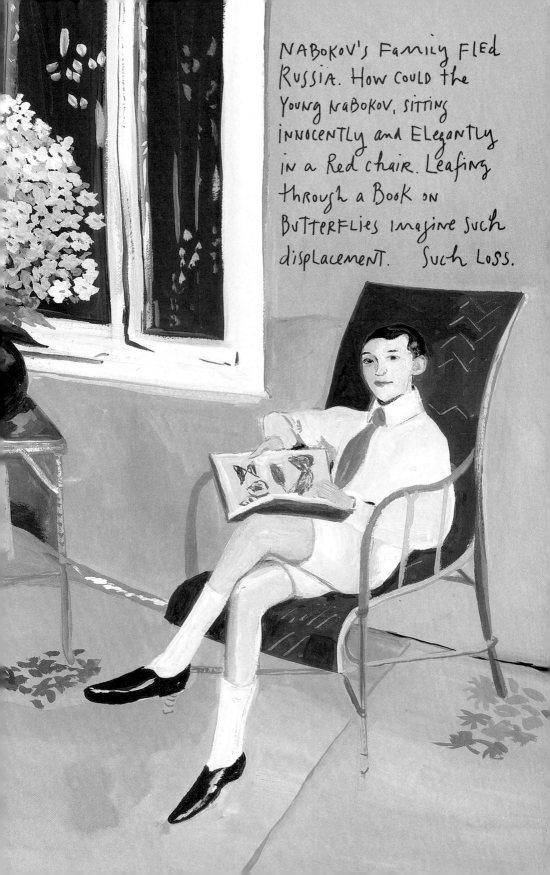

NABOKOV'S FAMILY FLED RUSSIA. HOW COULD the YOUNG NABOKOV, SITTING INNOCENTLY AND ELEGANTLY in a RED CHAIR. LEAFING through a BOOK ON BUTTERFLIES imagine Such displacement. Such Loss.

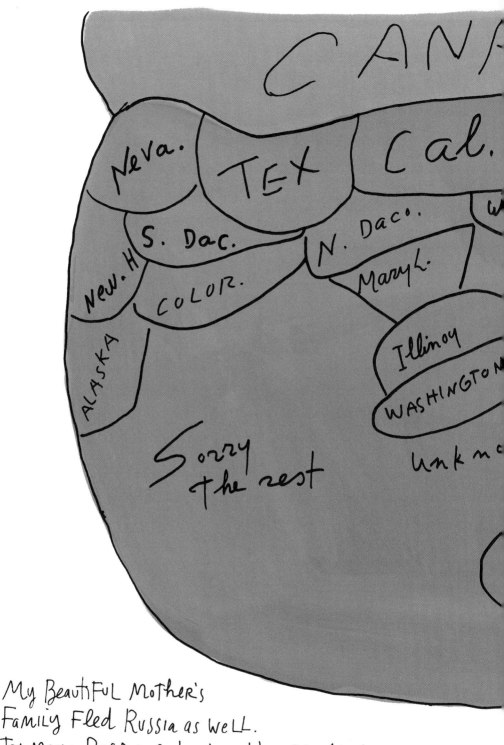

My Beautiful Mother's
Family Fled Russia as well.
Too many Pogroms. Leaving the shack, the wild
Blueberry woods, the geese, the River Slutch, they went
to Palestine. And then America.

DA

Verm.

...hing S.

S. Car.

N. Car.

Pitzb.

.C.

Mass.

N.Y.S.

HAWAI

Thank you

Flor.

New. Jersey

N.Y.S.

Jerusalem

T. A.

...ens.

N.Y.S.

Lenin

L.I

MY mother dRew this MAP FOR me.
This is the WORLD through HeR
EYES. She is NO LONger ALive.
and it is impossible to BeaR. SHe Loved FRed Astaire.
And there you go. ON you go. HapLess, heRoic US.

JUNE 7, 2006

●

Plenty of clouds will cover the region.
Scattered showers will dampen the area.

~~THERE ISN'T ENOUGH TIME~~. NOT ENOUGH TIME.
WHAT IS ~~the~~ MOST IMPORTANT ~~thing~~? TIME.
(THERE ISN'T ENOUGH TIME) I HAVE
(~~INCESSANT~~ MANY) QUESTIONS BUT NO PATIENCE
TO THINK THINGS THROUGH. ~~AND WHAT does~~
~~that mean~~? ~~RIGHT NOW~~ WHAT IS the
DIFFERENCE BETWEEN THINKING AND FEELING?
IF YOU ~~COULD~~ HAD TO GIVE UP ONE, WHICH WOULD
IT BE? WHAT ~~IS LUCK, FATE~~? MISTAKES?
~~IF IN A UNIFIED THEORY~~. [NEVER MIND.] COHERENCE?

MY BRAIN IS EXPLODING.
TRYING TO MAKE SENSE OUT OF NONSENSE,
TRYING TO TELL you EVERYTHING (EVERYTHING?)
AND ALL the while time IS FLEEING.
AND the air AROUND ME VIBRATES with SO
MANY IMAGES. Which IS great BECAUSE MOST
OF them ARe BRITISH.

Like Cecil Beaton's photograph of his sister BABA BEATON in Fanciful dress.

And the splendid houses and gardens they visited:

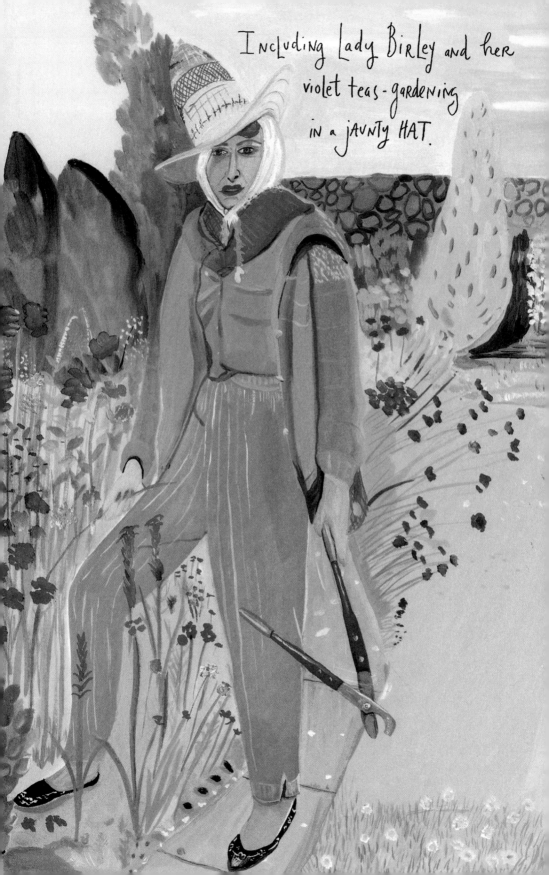

Including Lady Birley and her violet teas-gardening in a jaunty HAT.

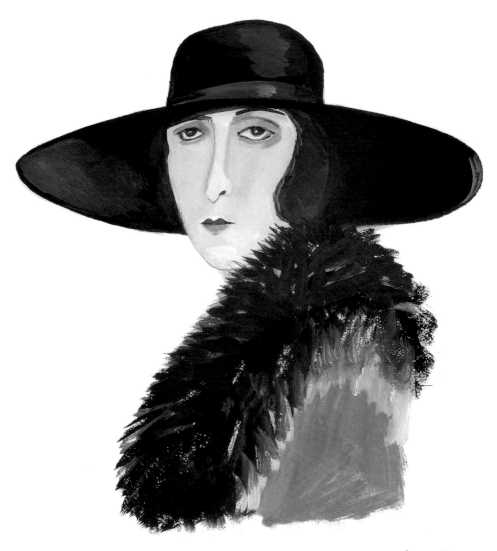

Including the White Garden at Sissinghurst
designed by Vita Sackville-West, who was
 Long and Lean and in Love with Virginia Woolf.

But then I found, (stuck in a book about Moss)
my postcard of an 18th-Century Female HERMIT in a
SMART SCHIAPARELLI-Type TURBAN, which makes me think
OF THE JOYS OF HIDING and
The ALLURe OF FASHION
AND MY Adoration
of JAUNTY
HAT
WeaReRS-

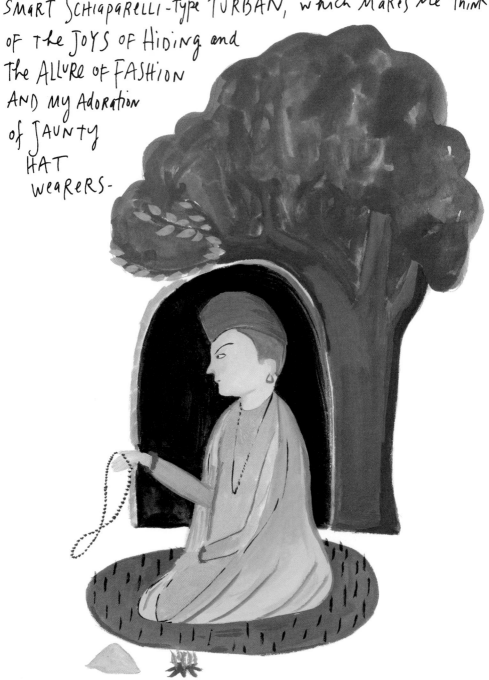

16

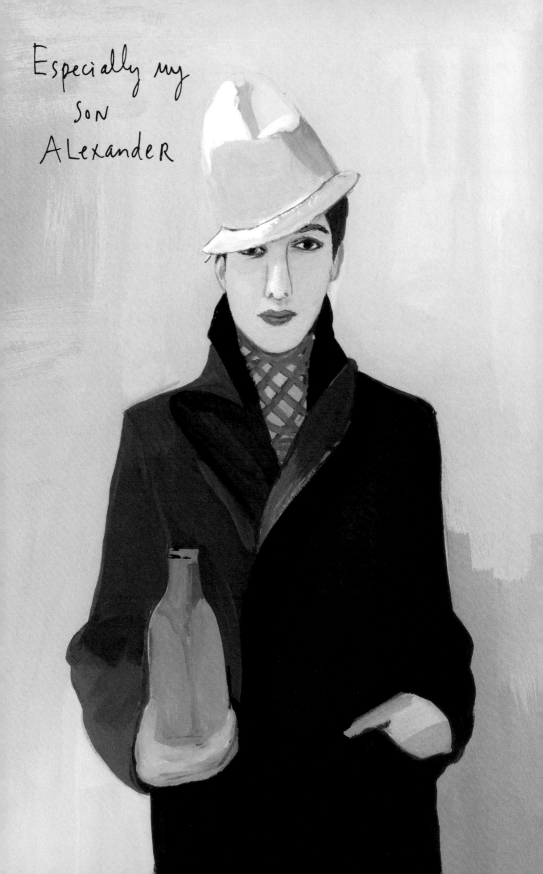

Especially my
son
Alexander

and my daughter
Lulu,
who
I
call
MILTON.

In honor of that nickname, my sharp-eyed friend Molly Bloom (YES), stopping at a flea market and short on cash, traded 10 lemon tarts she was bringing to a dinner party for a cigarette case with MILTON FINE finely etched on the FRONT.

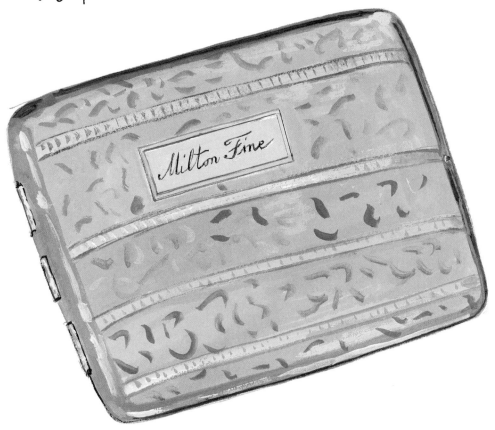

There was one obvious thing to do.
I called Milton Fine in the phonebook to
find out if he was the owner. He was NOT.

But what we DID discover was that he
WAS the social studies teacher at the junior
high school my sister and I went to in
bucolic Riverdale, the Bronx. And my sister was
in his class. And he REMEMBERED her. Get out!

There was one obvious thing to do.
Invite Milton to lunch, with my sister.

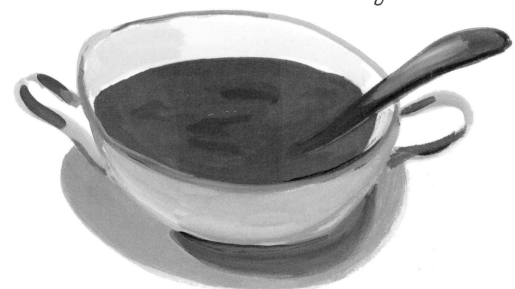

We all ate tomato bisque soup and
in between SLURPS looked at each other
looking for the past.

We spoke of MR. KAFKA, the UNHappy ORCHESTRA Teacher,

and MISS COVINO of the FLUTTERING EYES and LOVELY FLIP Hairdo.

OF MISS SMALLINE, who had a GIGANTIC BOUFFANT Hairdo,

and MRS. EINSTEIN who was the sixth-grade MATH teacHeR!

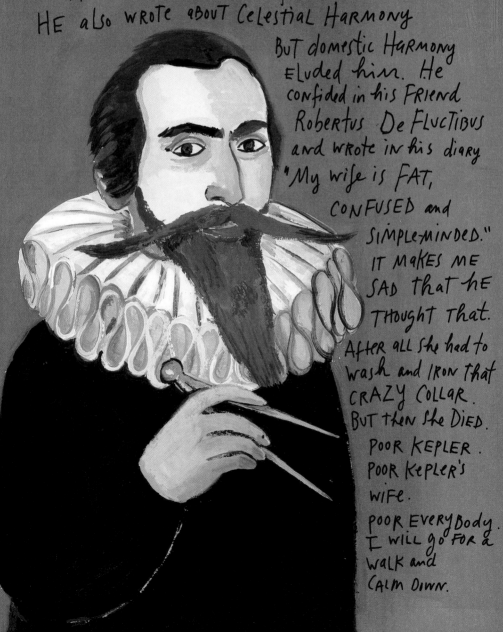

The Real Einstein (ALBERT, who played the VIOLIN BADLY; BUT SO WHAT. There is NOTHING greater THAN MUSIC NOTHING) loved Johannes Kepler. And if Einstein loved Kepler, I LOVE KEPLER. IN 1605-ish the genius Kepler determined (without a telescope) the ELLIPTICAL orbit of Mars — while wearing a RUFFLED COLLAR the size of a SNOW TIRE.

HE also WROTE about Celestial Harmony

BUT domestic Harmony eluded him. He confided in his FRIEND Robertus De Fluctibus and wrote in his diary "My wife is FAT, CONFUSED and SIMPLE-MINDED." IT MAKES ME SAD that HE THOUGHT That. After all she had to wash and IRON that CRAZY COLLAR. BUT then she DIED. POOR KEPLER. POOR KEPLER's WIFE. POOR EVERYBODY. I WILL go FOR a WALK and CALM DOWN.

JULY 5, 2006

●

Humidity lessening.
Showers and perhaps a rumble of thunder.

My dream is to walk around the world.
A smallish backpack, all essentials neatly
in place. A camera. A notebook. A
traveling paint set. A hat. good shoes.
A nice pleated (green?) skirt for the
occasional seaside hotel afternoon dance.

I don't want to TRUDGE UP INSANE MOUNTAINS OR through WAR-TORN LANDS. JUST a NICE STROLL through hill and dale.

But NOW I walk everywhere in the CITY. Any city. You SEE everything you Need to See for a Lifetime. EVERY emotion. EVERY CONdition. EVERY FASHION. EVERY gloRy.

I could go on about the MagNIFICENT chairs I have seen,

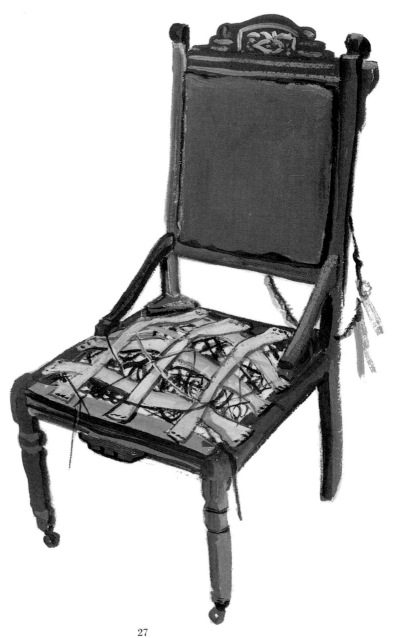

OR the EXCELLENT united Pickle
tag Lying on the sidewalk.

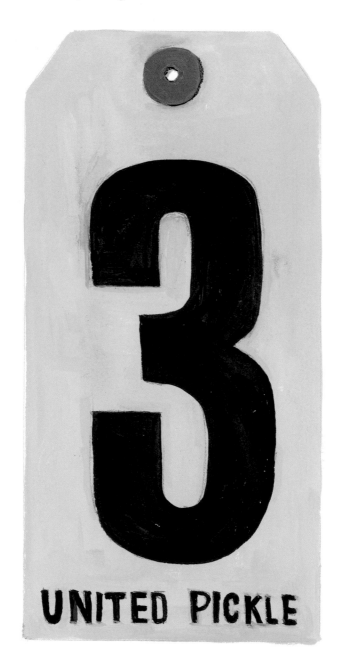

OR the candy-striped water tower,

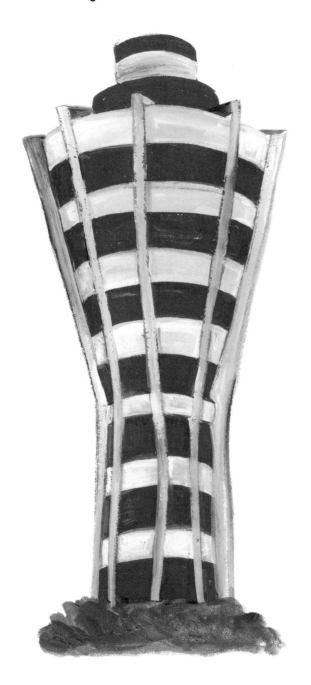

OR the fabulous giant pom-pom hat,

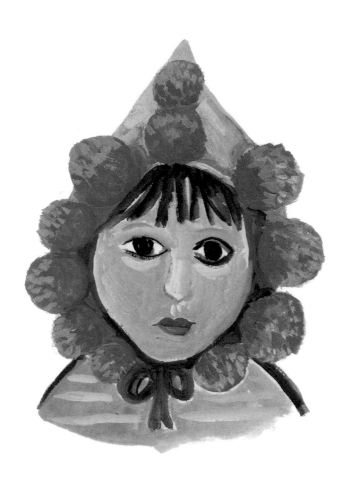

OR the GRACEFULLY GRACEFULLY Building.

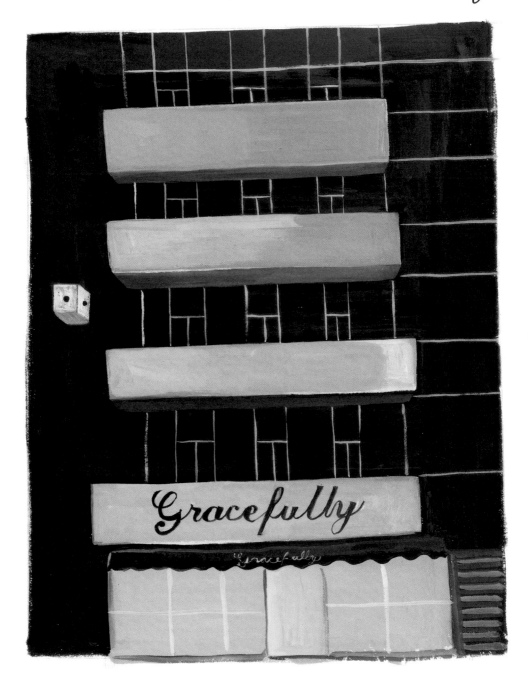

or the sidewalk store
with the bucket and shoes.

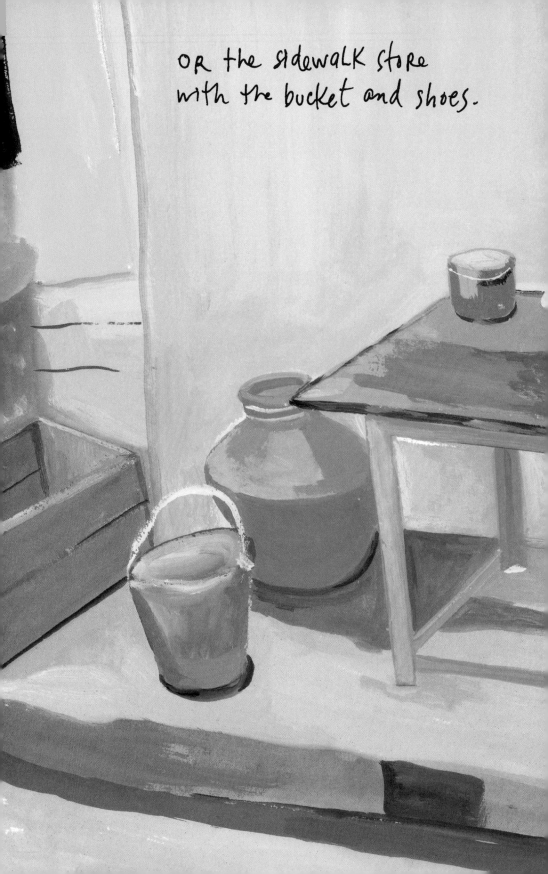

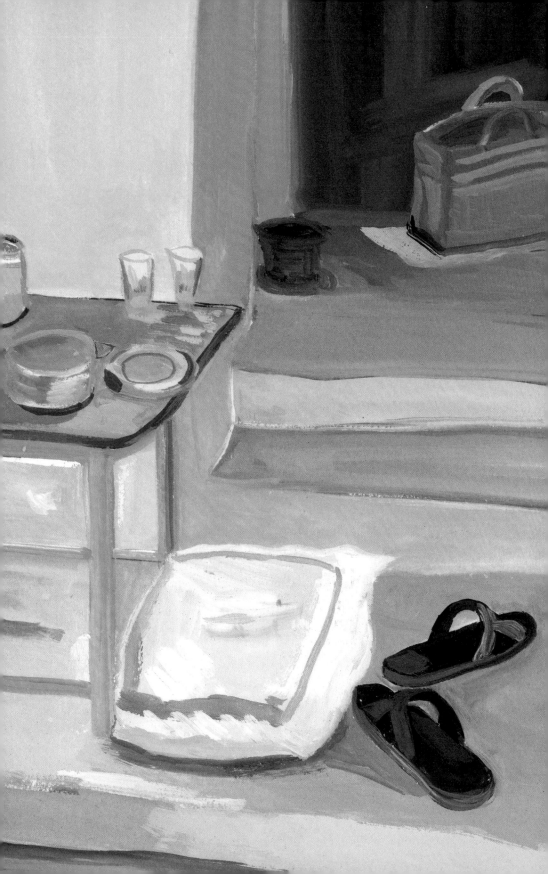

ALL TeRRiFiC.

BUT

the People.
THE PEOPLE.

EVERYONE Looks so exalted,
OR so WRETCHED, OR so spiffy,
so FUNNY,

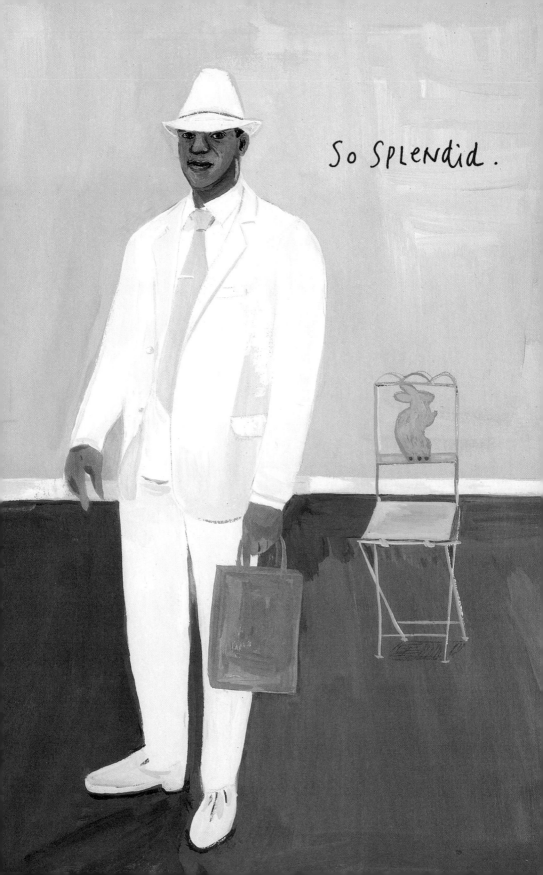

So Splendid.

IF YOU aRE EVER BORed oR BLUE,
STaND oN the STREET coRNeR FoR
HaLF aN HouR.

I HaVE a SpecialTy oF LoVE —
OLD People who haVE diFFiculTy walKing.
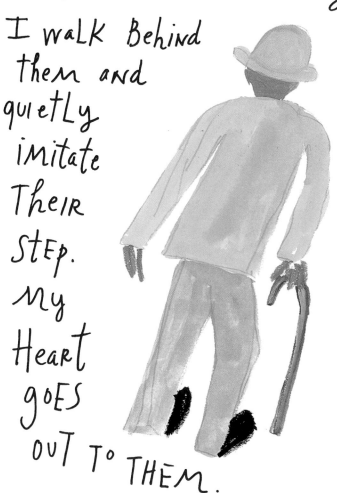
I walK Behind
them and
quietly
imitate
TheiR
STEp.
My
Heart
goES
ouT To THEM.

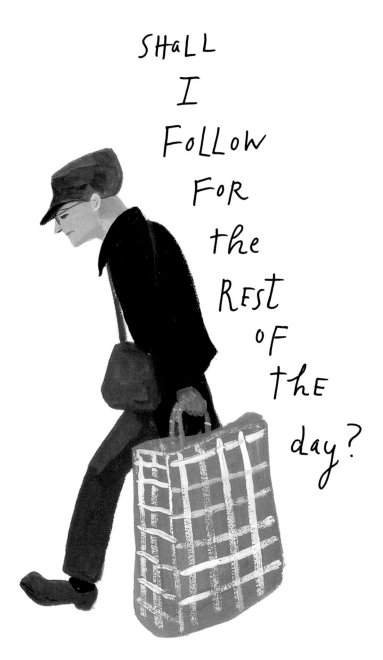

SHALL
I
FOLLOW
FOR
the
REST
OF
the
day?

SHaLL
I
OFFeR
HELP?

SIT and Read with them?

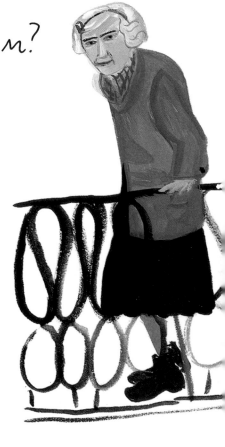

Clean Their
Houses
and
Make
Them
Lunch?

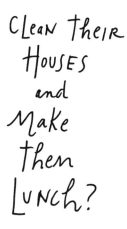

40

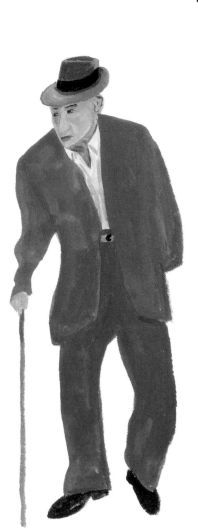

STEP,

STEP,

STEP.

Soon enough it will Be ME
STRUGGLing (valianTly?) to walk-
Lugging my STUFF aRound.

How aRe WE
aLL So BRaVE
as to take
STep
afTeR
STep?
Day
afteR
day?
How aRe we so
optimistic, so caReFul
Not to trip and yet
DO Trip, and then
GET up and say O.K.
Why do I feel So SORRY
FoR everyoNe and So PRouD?

Angels walking on the earth. Cherubim and Seraphim.

I take pictures of people, but not EVERYONE is so pleased to be photographed.

I suppose not everyone is that angelic.
FiNE by Me.

AUGUST 2, 2006

•

Stifling heat.
High 100°.

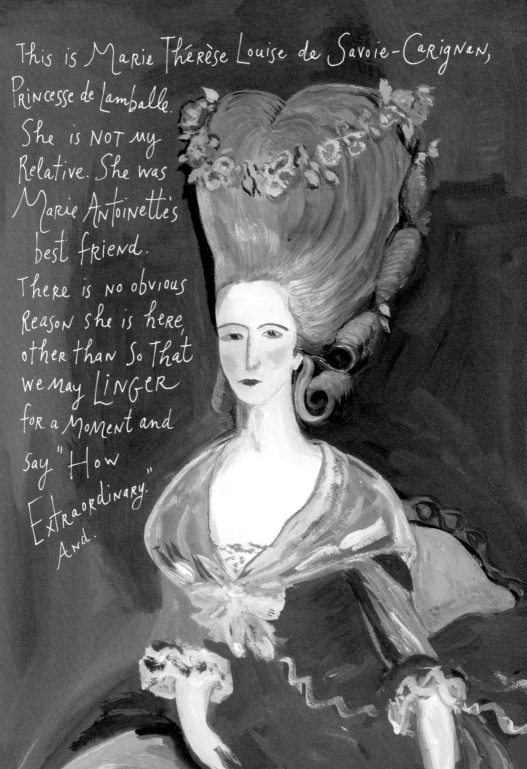

This is Marie Thérèse Louise de Savoie-Carignan, Princesse de Lamballe. She is NOT my Relative. She was Marie Antoinette's best friend. There is no obvious Reason she is here, other than So That we may LINGER for a Moment and say "How Extraordinary." And.

What can I tell you?
The Realization that we are ALL
(YOU, ME) going to die and the
attending DISBELIEF—
isn't that the
CENTRAL PREMISE OF
EVERYTHING?

It STOPS me DEAD in my TRACKS
a DOZEN times a DAY. Do YOU THINK
I Remain FROZEN? NO. I SPRING into
ACTION. I FIND Meaningful DISTRACTION.

Lately I have become enamored with Fruit Platters. I paint them.

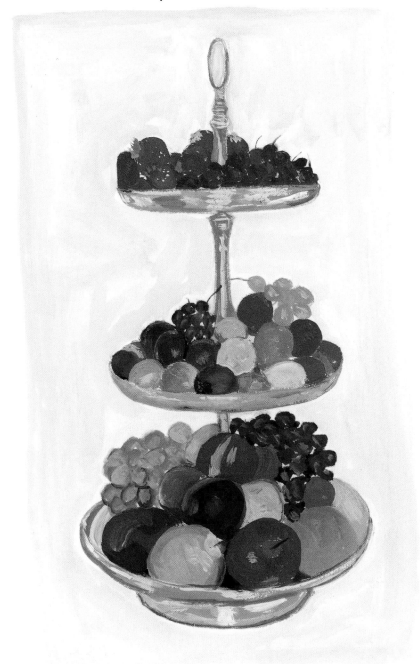

Italian Fruit Platter

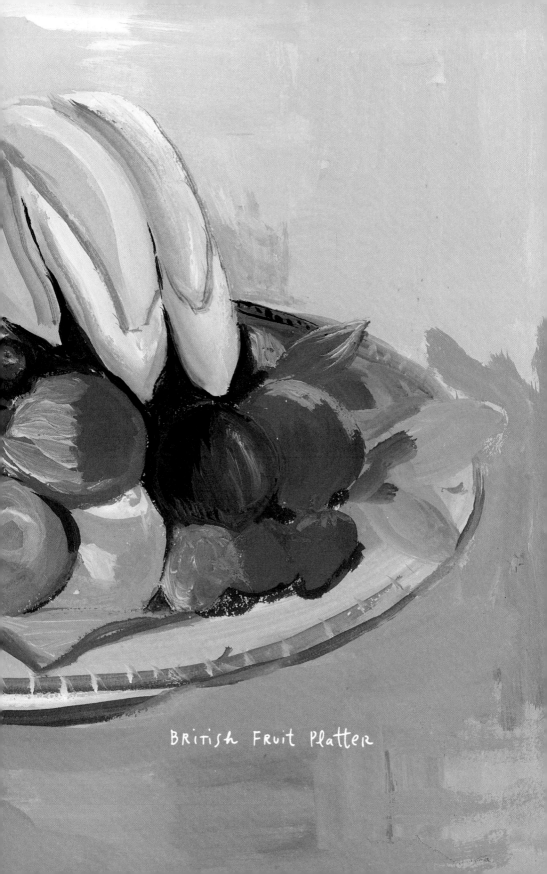

BRiTiSh FRuit PLatteR

But that is not all I do for distraction
and diversion.
I read the obituaries first thing
in the morning.

With a cup of coffee.

This is not morbid. Just epic.

Maybe it is a way of trying to figure out,
before the day begins, what is important.
And I am curious about all the little things
that make up a life. Little?

My Favorite obituary is that of Megan Boyd.
She lived in a tiny village in Scotland and
spent her life making exquisite flies for
the local fisherman and for Kings.

She wore a jacket and tie, skirt and boots.
Sitting at her table for 18 hours a day,
she sought a perfection that consumed her.
Her diversion was the occasional clog
dance in the village.

Sometimes, when I imagine my own death,
I believe I will be reunited with my loved ones.
We are all floating around in a fluffy sky.

I get a delicious cozy feeling.
But then I remember that even my loved
ones are sometimes very IRRITATING and even
INFURIATING — so what is that about? And
what would we <u>do</u> all day FOREVER?

Besides, the whole thing is INSANELY UNLIKELY.
I prefer the notion of Heaven on Earth.
Of sweet, funny, loving moments.
For me, heaven on earth is my
Aunt's kitchen in Tel Aviv.

My aunt is 88.
UNTIL RECENTLY
she swam in
the OCEAN
at DAWN
every day of
the YEAR.

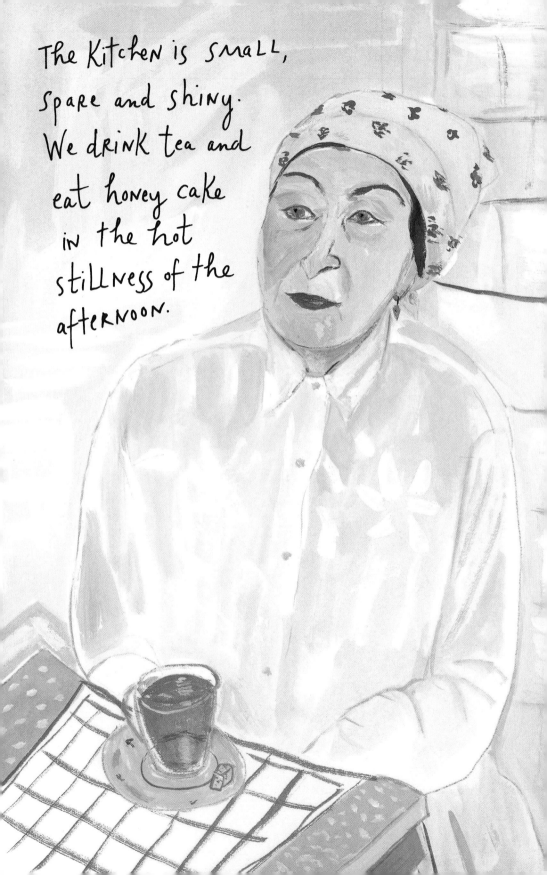

The Kitchen is small, spare and shiny. We drink tea and eat honey cake in the hot stillness of the afternoon.

There are four of us in the family who make this cake. My aunt bakes hers in a stove called The Valiant.
We use a bundt pan.

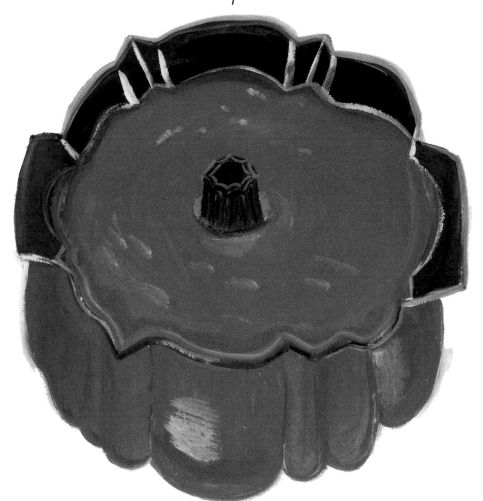

The inventor of the bundt pan, H. David Dalquist, died last year. He had a very good obituary.

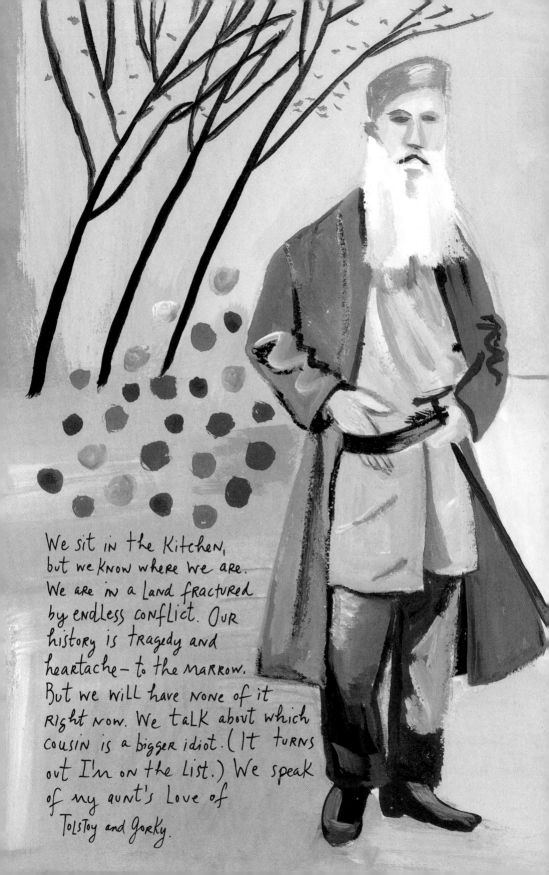

We sit in the Kitchen,
but we know where we are.
We are in a land fractured
by endless conflict. Our
history is tragedy and
heartache — to the marrow.
But we will have none of it
right now. We talk about which
cousin is a bigger idiot. (It turns
out I'm on the list.) We speak
of my aunt's love of
Tolstoy and Gorky.

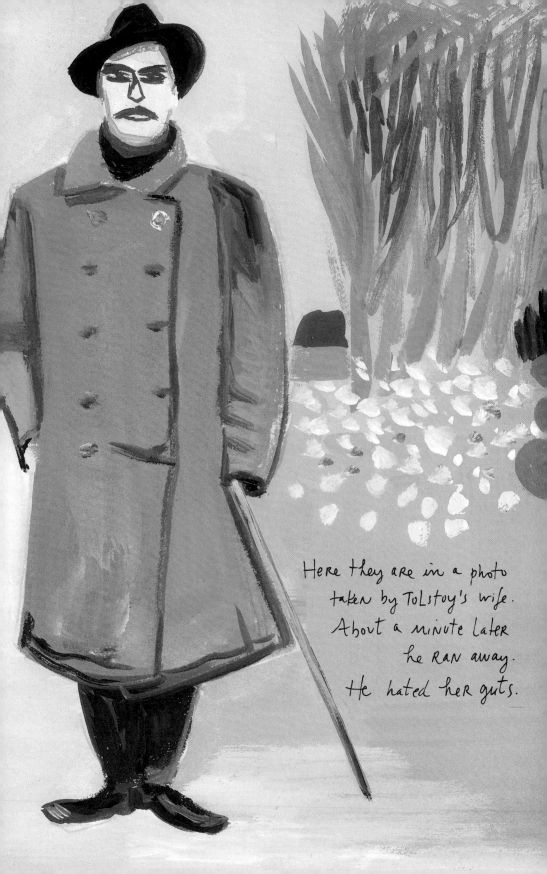

Here they are in a photo
taken by TOLSTOY's wife.
About a minute later
 he RAN away.
 He hated heR guts.

We talk about Dostoevsky—

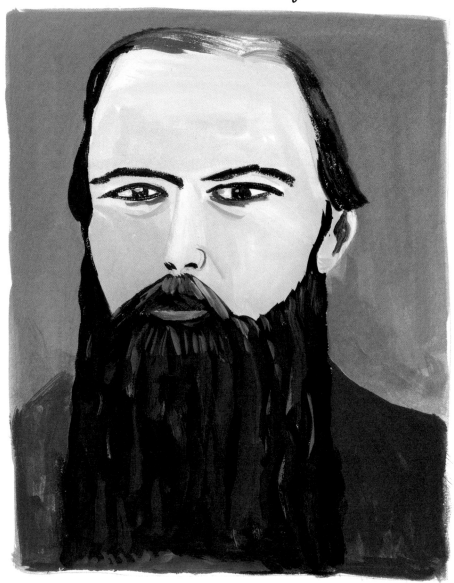

His epilepsy, alcoholism, gambling addiction and chronic debt.

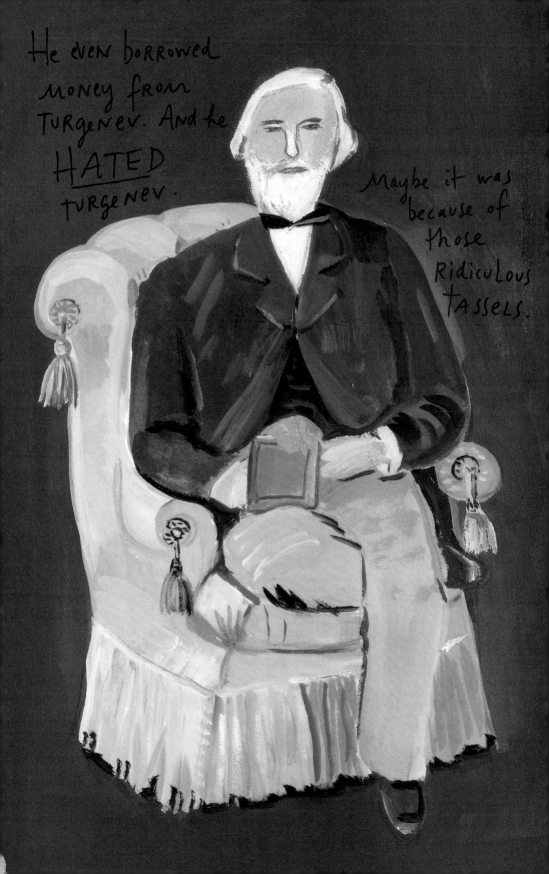

He even borrowed money from Turgenev. And he **HATED** Turgenev.

Maybe it was because of those Ridiculous Tassels.

We discuss Dostoevsky's miserable love life.
He was madly in love with

POLINA SUSLOVA,

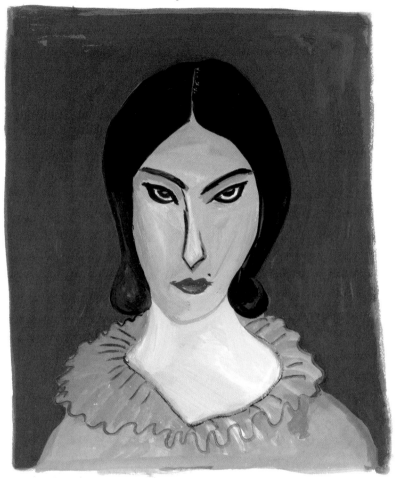

but she DETESTED him — and
left him for a Spaniard who
then left her. It was a big MESS.
And while all this is going on,
he writes these Genius books.

My aunt tells me about Maishel Shmelkin, the genius of Lenin (the village in Russia my family came from, named after the Princess Lenina) who once forgot to put his pants on when he went for a WALK.

We talk about my
mother and why
she did NOT MARRY
the man she LOVED,
but instead married
my father, who
accidentally fell
out of the 2nd-FLOOR
window of our
apartment in
TeL-Aviv, but
bounced and
did not get hurt.

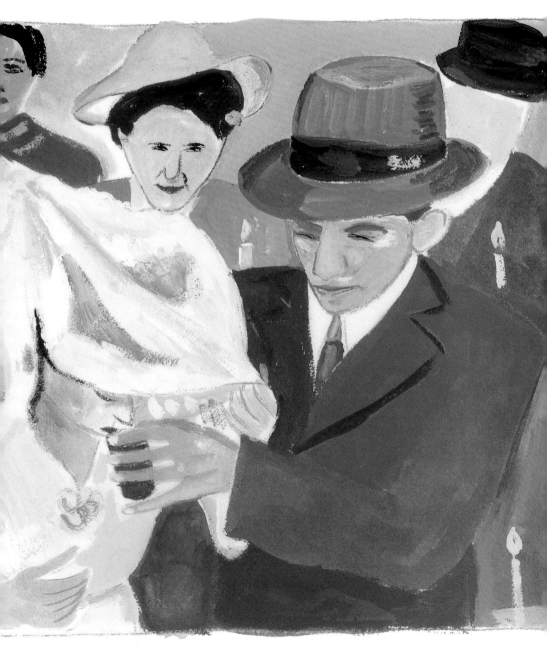

Perhaps that is why
he was a little crazy.

When he was in a nursing home, with Alzheimer's (and was so sweet - a sweetness he did not have in his normal life) his best friend there looked like Humpty Dumpty, carried a lunch box and listened to Brahms.

My father saw invisible people. A woman there thought that leaves were her eyeglasses. What world were they in? Unfathomable.

More tea. More stories.

There is Nothing ILLUSORY
IN this TINY heaven.
I am silent with gratitude.
I will go and bake a honey cake
and that's all.

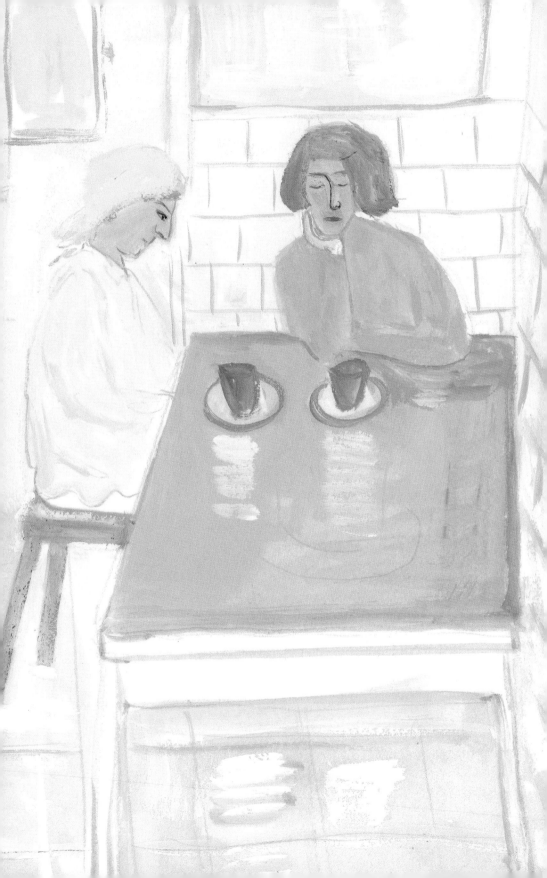

SEPTEMBER 6, 2006

•

Turning brighter.
Fog will form toward daybreak.

My sister and I go to Israel
during the SHORT, FURIOUS
the WORLD-is-doomed WAR.
FoR a wedding.
Because you CANNOT postpone weddings
in DARK Times—Especially in daRk times.
Who Knows when the Light will
come on again.
ARe things NoRmaL? I don't Know.
Does Life go on?
YES.

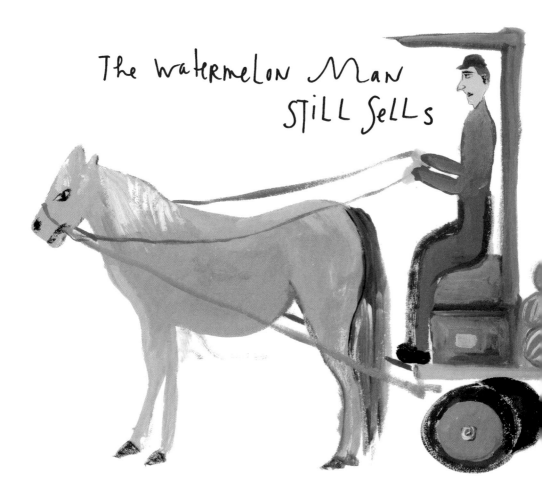

The Watermelon Man
Still Sells

watermelons
from his
cart.

The ice cream Man Still

sells Lemon ices on the Beach.

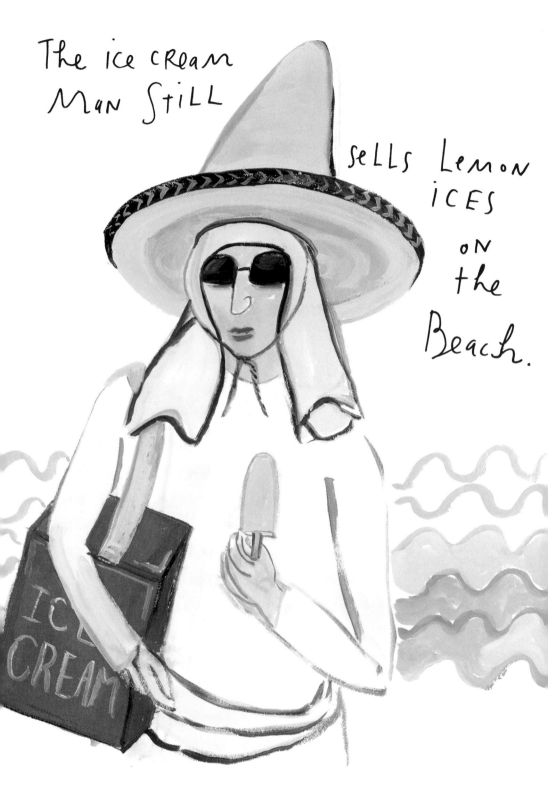

We STILL Rummage around the Flea Market in Jaffa. I find a Keychain without Keys but with a photo of the owner – 13 year-old (in 1966 as it says on the Reverse side) Nachum Mishkovitzky. Where is he now?

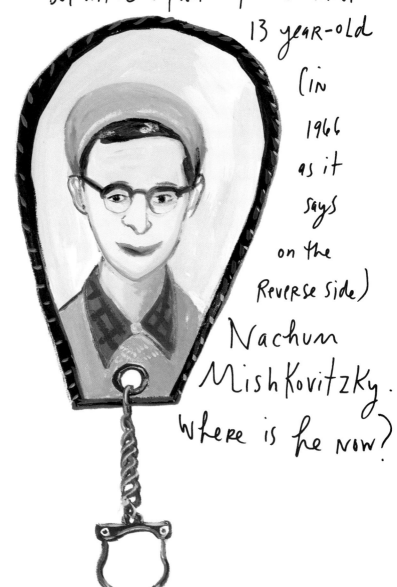

We STILL go to the ARaB Restaurant
called The Old Man and the SEA,

which still serves 20 different appetizers
all at once and GIANT HoT pitas.

MRS. Mandlebaum and MRS. Lipski STILL take their evening STROLL by the YARKON RIVER.

MRS. LIPSKI's daughter has just started speaking to her again — AFTER 23 years.

The Secondhand Bookstores
 are STILL crammed with
secondhand books and
 Secondhand book Readers.
I find a guidebook to
 the summer palace in
St. Petersburg. It does
 not matter that I
can't Read Russian. The
 only thing that matters
is the photo of the crazy
 great giant vase in
 the garden.

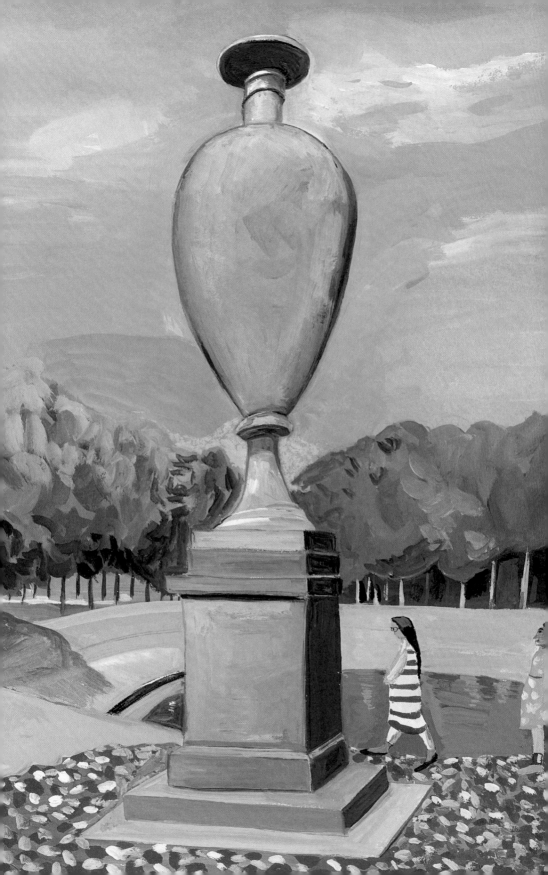

The FRANGIPANI tree STILL BLOOMS ON SPINOZA STREET. I STOP TO LOOK AT a Bauhaus Building.

A MAN who is cleaning away Rotting cherries that have fallen from a tree onto his car ROOF accidentally FLICKS one onto my NECK — SPLaT— Staining my CRISP, white SHIRT. He gives me a Lame, smirky apology and I think "WHAT A JERK!"
Is there Room for Pettiness duRing a WAR? ARe you Kidding?

My sister and I go to visit my mother and grandparents in the cemetery. It is evening. The birds are chirping, oblivious to where we are. I stand before the graves and silently implore them to do something to stop the war. They must talk to someone who knows someone — pull some strings. They must use some Heavenly Cosmic Force to bring about peace in the Middle East. In the world. I beg them, but they do not respond. Silence. The graves are silent. The cedars are silent. The dust is silent.

So we leave.

And pass a waterfall
of PINK Bougainvillea.

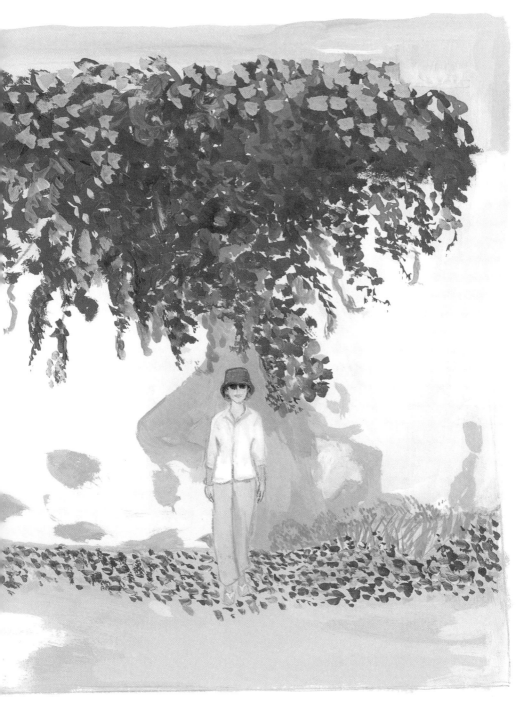

I photograph my sister and think she looks so Beautiful in her PINK Hat. What will happen to her? What will happen to us ALL?

I RETURN to New York. TIRed. Sad.
The WORLD is coming to an END.
What to do? what to do?

I KNOW what to do.
Spend the day on the subway.
Oh wonderful Life-affirming
 two-dollar subway Ride.
I go with Rick. He wears a straw
Hat and he will take pictures.
It is August. Hot, but not too hot.
We take the F TRain To Coney Island.

Two girls on their way to the Aquarium
have tied T-SHIRTS around their heads
 and they are DANCING.

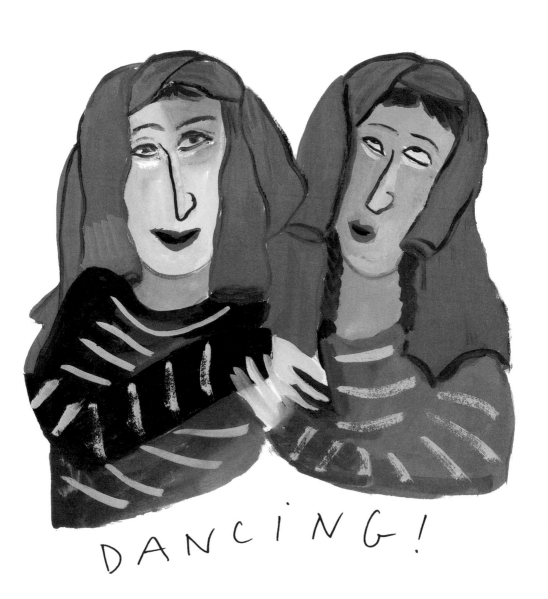

DANCING!

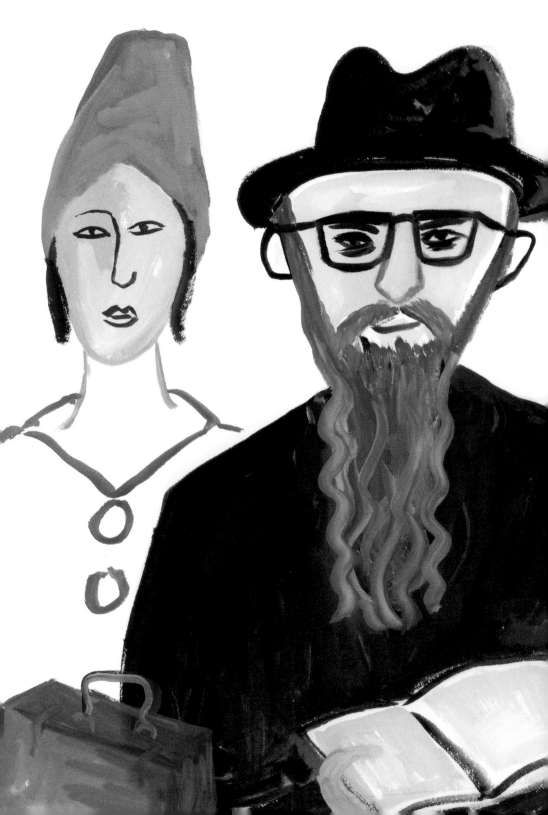

A man in a Black hat
and scraggly Beard Reads a book.
A woman next to him has a
green hat and does not Read
a book. The man takes his
BROWN suitcase and gets off
at DELANCEY STREET. THINGS
ARE
LOOKING
UP.

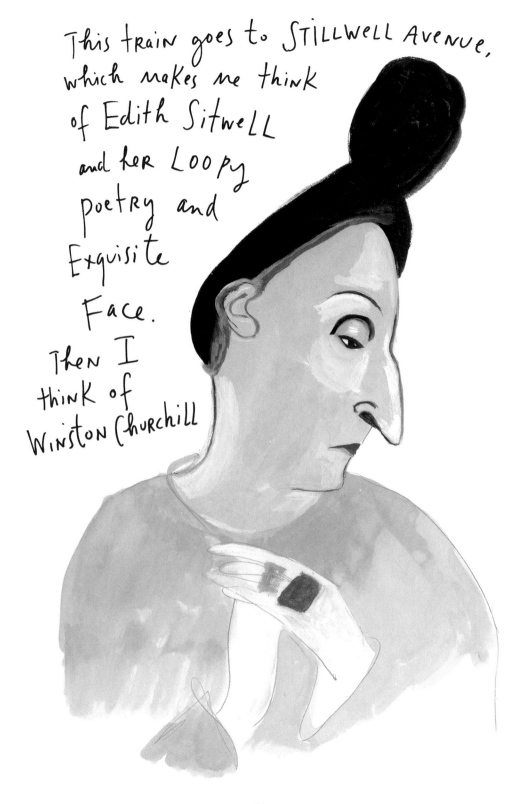

This train goes to STILLWELL AVENUE, which makes me think of Edith Sitwell and her LOOPY poetry and Exquisite Face. Then I think of WINSTON Churchill

and his serene and charming paintings.

I think of his BULLdog tenacity and solid optimism. Winston, where are you Now?

On the sunny platform of Avenue U, a woman reads

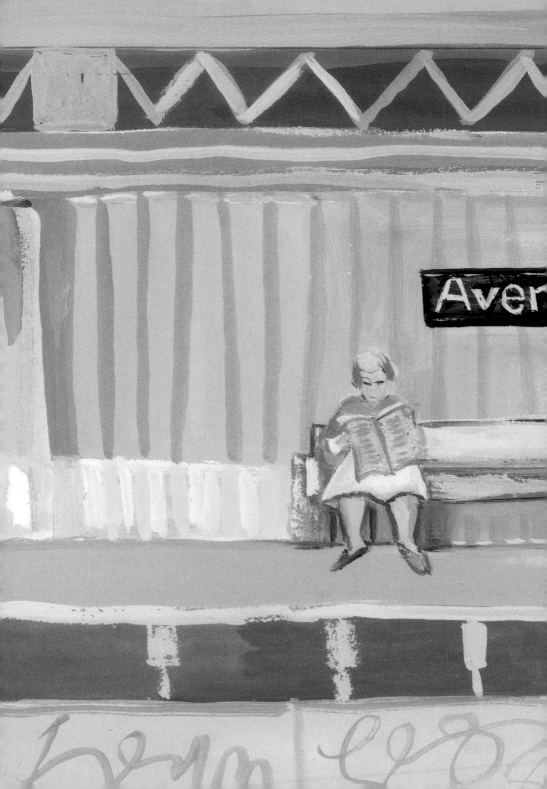

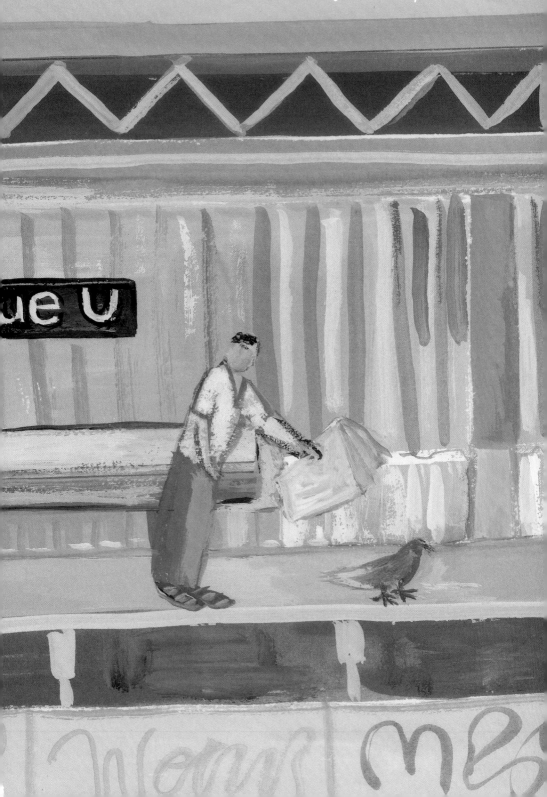

We get off at Avenue X to take a
look around. How could we not?
We pass the Dental and Foot care clinic.

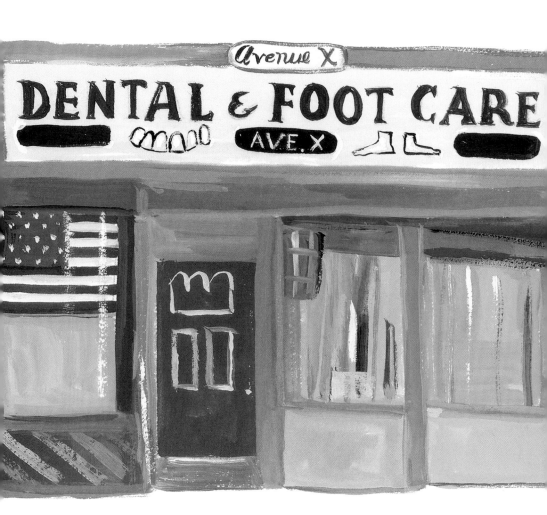

AgHH!

At Cuccio's Bakery we see a
SEVEN-LAYER CHOCOLATE Cake with
a CHERRY ON TOP.

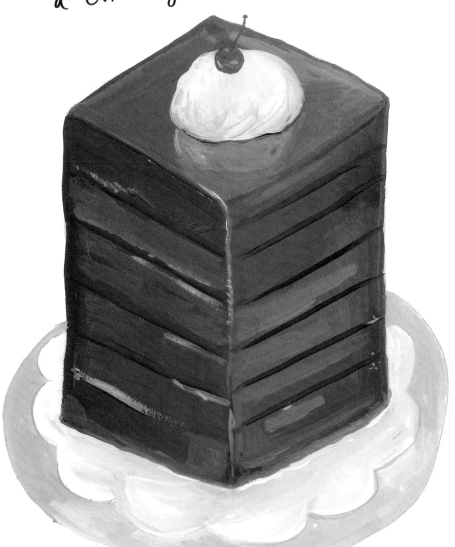

A SEVEN-LAYER CHOCOLATE CAKE
with a CHERRY ON TOP !!

WE pass the ARTuro Toscanini Elementary School.
I would NOT want to have Toscanini for an
elementary School teacher. And though he Had
a Good Relationship with his manager Gatti-Casazza,

hE was a COLOSSAL TyRANT and would NOT
Let his daughter WANda SING
BECAUSE hER VOICE
HuRt His
EaRS.

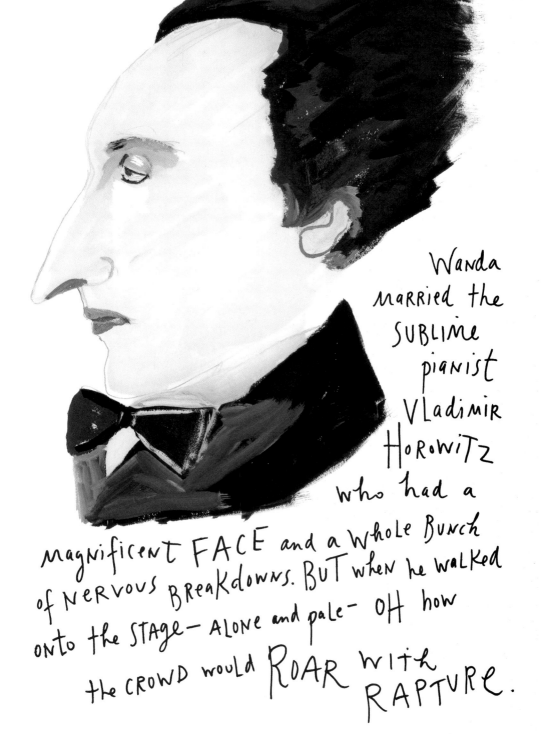

Wanda married the SUBLIME pianist VLadimir HOROWITZ who had a magnificent FACE and a whole Bunch of NERVOUS BREAKDOWNS. BUT when he walked onto the STAGE — ALONE and pale — OH how the CROWD would ROAR WITH RAPTURE.

We get back on the
train and get off at
CONEY ISLAND.
We see major hairdos.
I mean
MAJOR
HAiRdos.

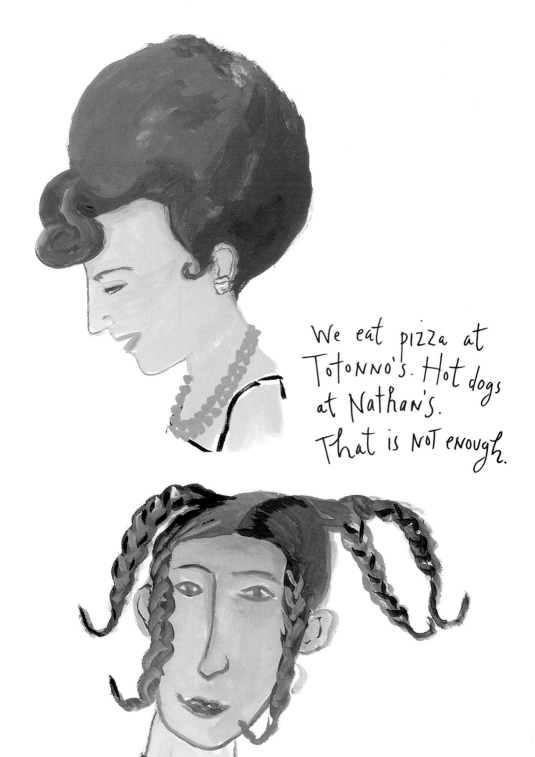

We eat pizza at Totonno's. Hot dogs at Nathan's. That is not enough.

We walk to Brighton Beach to a Russian deli and order hot tea and apple strudel from the tough-as-nails waitress who

is slicing giant Radishes.

We buy NUTS. FIGS. CHERRIES. GRAPES.
A white enamel SOUP POT. Some ORANGE
RUBBER GLOVES. SILVER and gold WONDER-
SCRUBBER SPONGES. A BALL OF STRING
(Because I always buy STRING when I
go on a TRIP.)

We get back on the train to go home—
carrying all these bags. I couldn't be
happier. And my sister's hat is very
pink. And the cedar trees will continue
to grow in Lebanon and Israel too. I hope.

OCTOBER 4, 2006

●

Summerlike, sunny.

How do you KNOW Who you aRe?
Half the time I don't KNow who
I am. MaYBe EVEN SEVEN EiGHTH'S.
NEVER MiND. ForGET iT. FoR-GET-iT.
But How cAN I FoRget it?
Does it have something to do with
LaNguage?
EVERYthing I say — I RegRet saying.
What if I did Not speak?
IF you came to my house and we
Sat at the Kitchen table and had
a cup of CoFFee with cReam that
I had just pouRed from this pitcher,

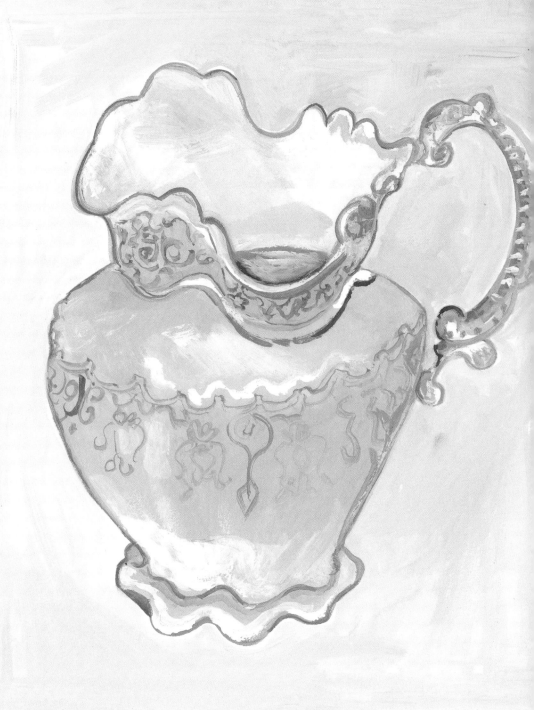

what would happen?

We could stare out the window

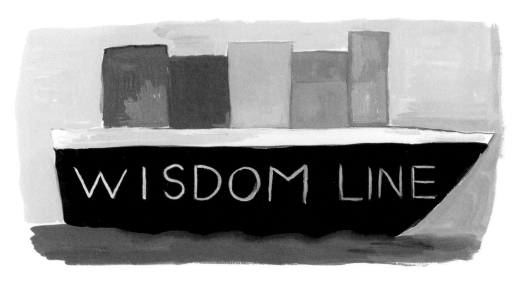

and watch a ship from the
Wisdom Line! pass by.

But let's say you were Hoping
for a piece of cake with your coffee.
You could ask me for that.
Then I would say that talking
is good for conveying information.

For instance, I say "hello" to my Neighbor, "how are you?" and she says "my husband is crazy." Well, there you go.

If we did sit in silence, you might notice that there are many objects displayed around the apartment. Collections. Tangible evidence of history, memory. Longing, delight.

There is my empty box collection.

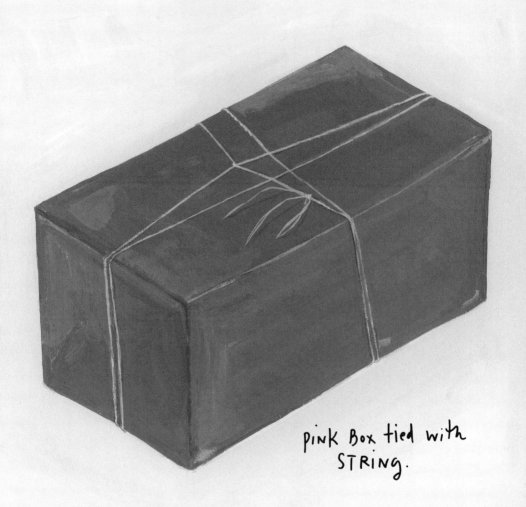

pink Box tied with
STRING.

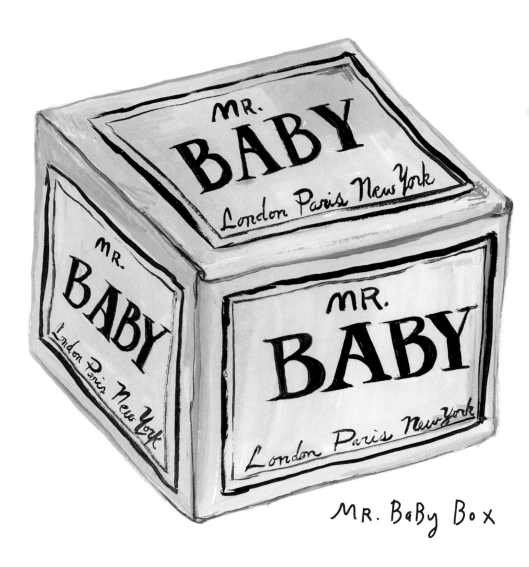

MR. BaBy Box

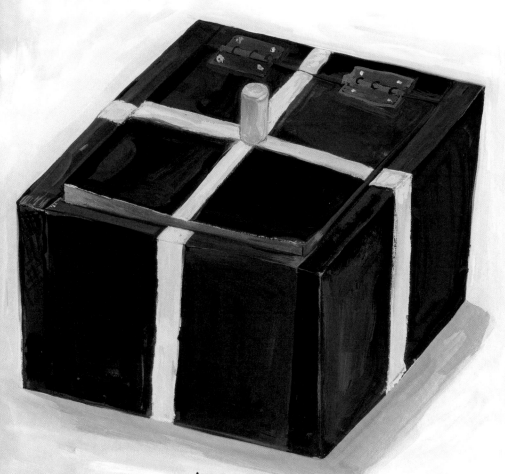

A wooden
box made by my daughter
when she was little.

WE COULD EXAMINE MY COLLECTION OF

sponges from around the world.

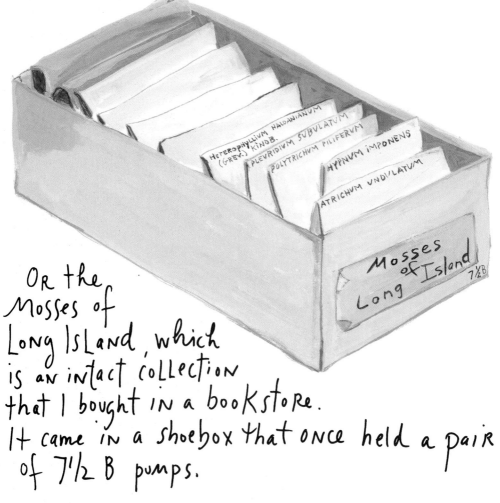

Or the
Mosses of
Long Island, which
is an intact collection
that I bought in a bookstore.
It came in a shoebox that once held a pair
of 7½ B pumps.

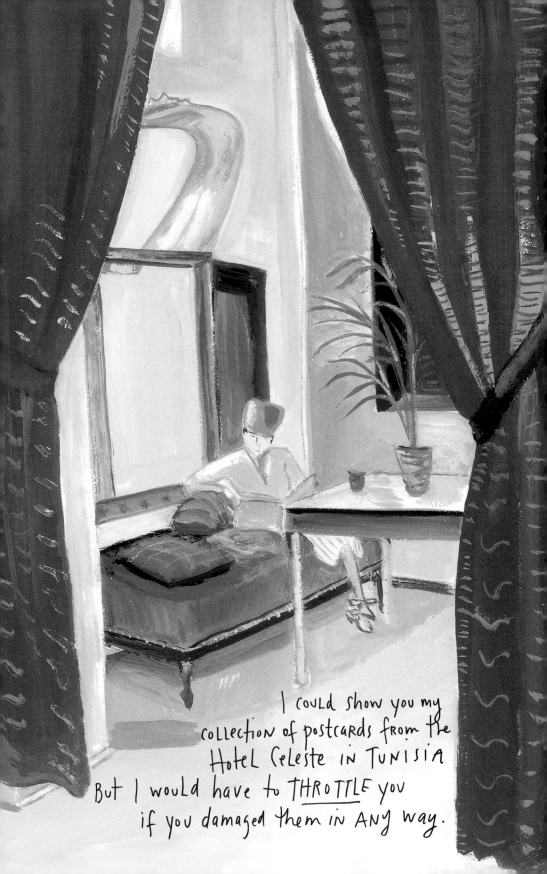

I could show you my collection of postcards from the Hotel Celeste in TUNISIA But I would have to THROTTLE you if you damaged them in ANY way.

You would smile at my WHISTLE collection and deFINITeLy want to TRy the one from the CIVIL WAR made by the HORSTMANN Co. iN PHILadeLphia.

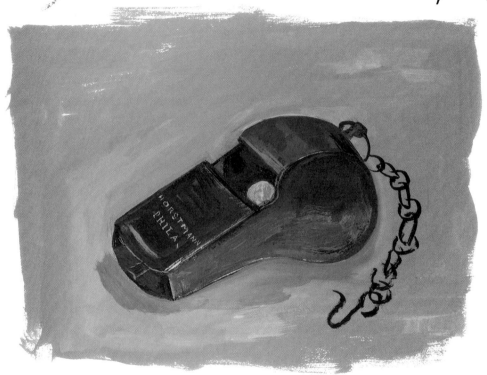

Maybe LincoLN heard this whisTLe BLOWN. MAYBe NOT.

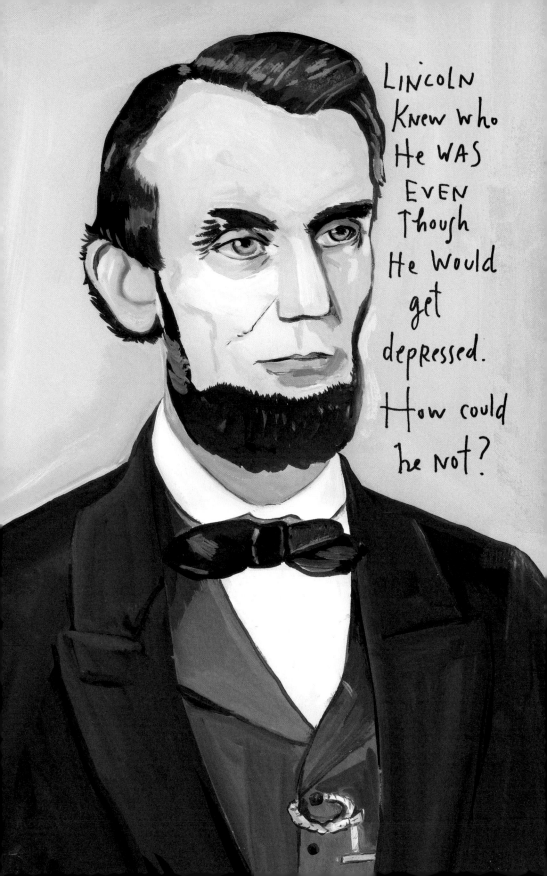

LINCOLN KNEW WHO HE WAS EVEN THOUGH HE WOULD GET DEPRESSED. How could he NOT?

I embroidered one of his quotes onto
a linen tablecloth for a show curated
by Chee Pearlman. I collect white
linen fabric from around the world,
and spend many happy hours ironing
and folding and looking at these things.

The Occasion is Piled High
with Difficulty. As our Case is
New, so we must Think Anew,
and Act Anew. We Must
Disenthrall Ourselves,
and
Then We Shall Save our
Country.
A. Lincoln
1862

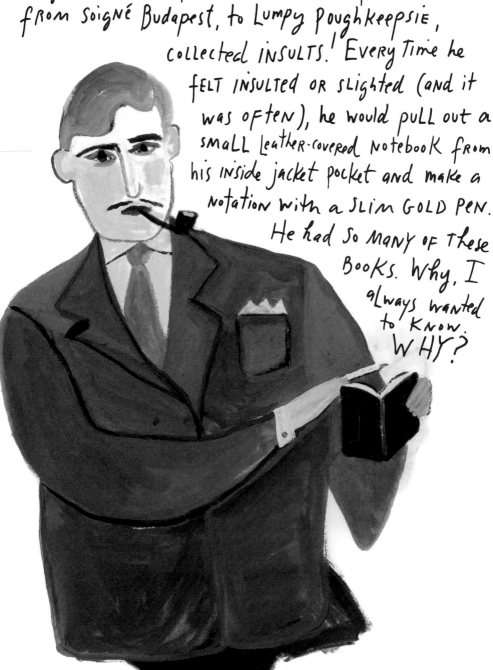

OF COURSE, IF WE ARE BEING HONEST, THERE IS OFTEN much we want to FORGET. OR SHOULD FORGET. My very aristocratic Father-in-law, transplanted in 1957 from Soigné Budapest, to Lumpy Poughkeepsie, collected INSULTS! Every Time he FELT INSULTED OR SLIGHTED (and it was often), he would pull out a small Leather-covered Notebook from his inside jacket pocket and make a notation with a SLIM GOLD PEN. He had So MANY OF These Books. Why, I always wanted to KNOW. WHY?

You might notice that there are ten suitcases in the middle of my Living Room. "going on a trip?" You might ask. "No."

One of them Belonged to a man who fled Danzig in 1939. As if I need Reminders of the Holocaust. That's ALL I think about.

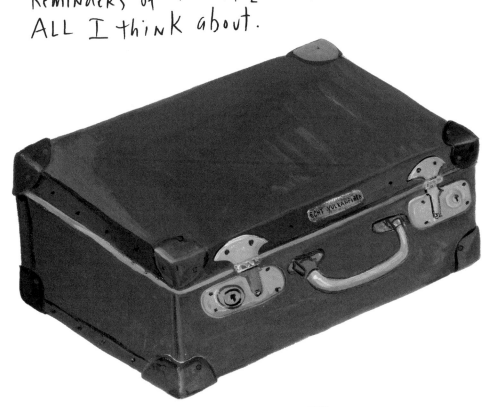

The suitcase was made by Josef Winker and Sons. Their shop was on Himmelpfortgasse Street.

Another suitcase was chanced upon
while I was walking up Park Avenue
with my friend Carol Weiss.
Collecting is the air Carol breathes
She does, in fact, collect air from
around the World.

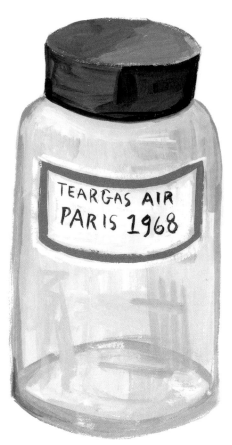

TEARGAS AIR
PARIS 1968

And Lint. And ephemera of all sorts.
It is her collective database, Her Lifelong
installation piece.

Carol is married to Professor Norman Weiss, a mathematician who collects nothing but extraordinarily complicated numbers in his head. He has a secretary named Minnie who looks a little worried. But who isn't?

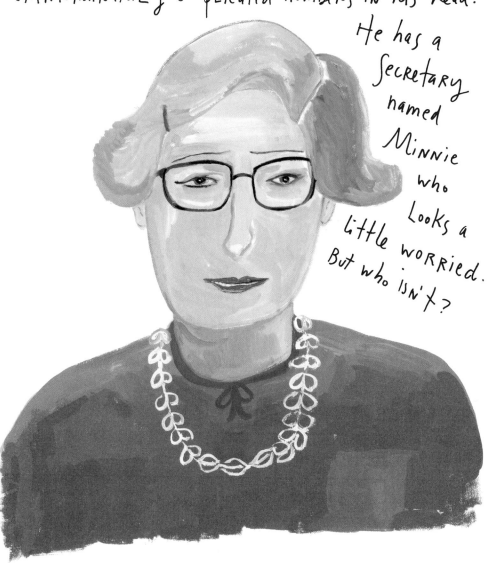

So, this suitcase that CAROL and I
found belonged (as the Label fuzzily
told us) to LORD and Lady
PENTLand!

They sailed
FIRST-CLASS on the BRITANNIC
(WHiTE STAR LINE - THINK TITANIC!!)
FROM ENGLaNd to New YORK in
the 40'S OR 50'S.

The HENRY VIII and HIS SIX WIVES
FINE MINT CHOCOLATE COLLECTION
is a FESTIVE PACKAGE

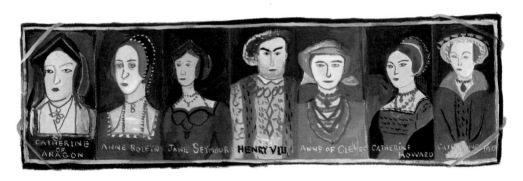

that happens to commemorate
Bloody murder and misogyny with
every bite. Hmmm.

It is well known how much Goethe loved candy. Not the giddy COLORFUL CHUCKLES

OR the psychedelic
WhiRLeY POP

BUT SERIOUS
GERMAN chocolate
TRUFFLES. I am
in the PROCESS of
PROCURING the GOETHE
BonBon dish.
Cannot wait.

Did Goethe
KNOW who he was?
The question is, does one NEED
to KNOW? And what is
it you KNOW once you
Think you KNOW?

I have embroidered Goethe's Lines from "FAUST" onto white fABRIC.

MY

RIGID

HEART

IS

TENDERLY

UNmanned

mk

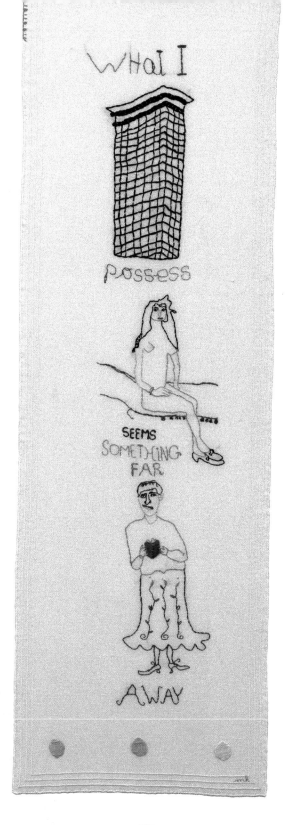

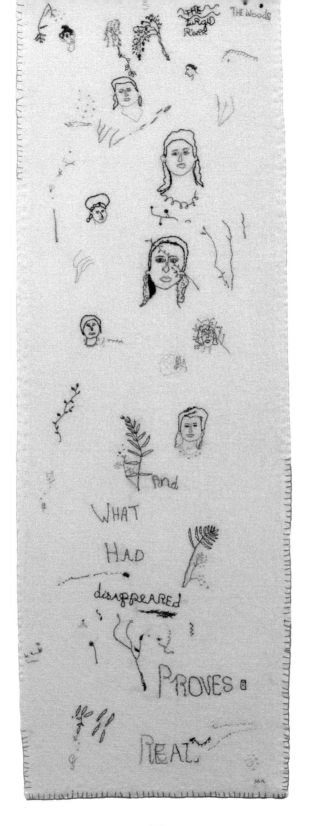

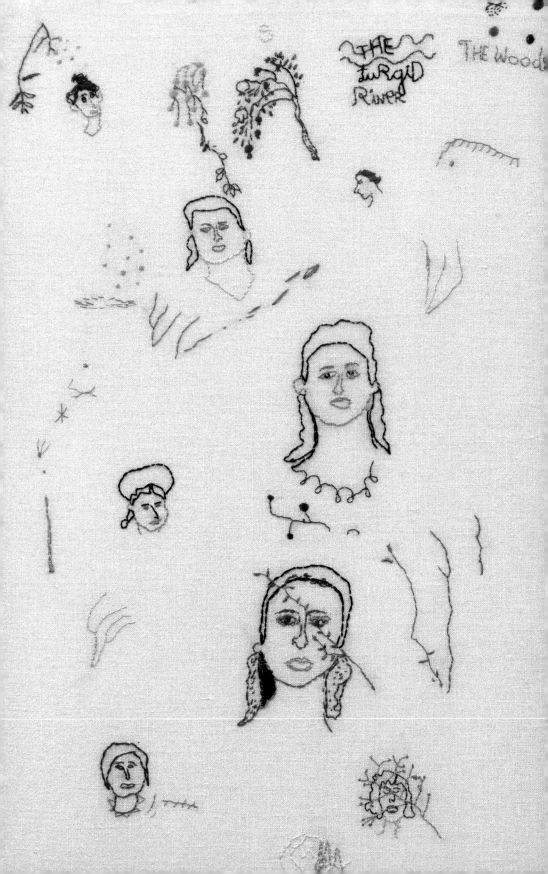

THE
TURGID
RIVER

THE Woods

And
WHAT
HAD
disappeared
PROVES
REAL

MK

NOVEMBER 1, 2006

●

Unusually warm weather
will persist.

We could speak about the MEANING OF LIFE vis-à-vis NON-CONSEQUENTIAL/DEONTOLOGICAL Theories, APODICTIC TRANSFORMATION SCHEMATA, The incoherence of EXEMPLIFICATION, Metaphysical Realism, CARTESIAN INTERACTIVE DUALISM, REVISED NON REDUCTIVE DUALISM, POSTMODERNIST GRAMMATOLOGY AND DICEY DICHOTOMIES. BUT WE WOULD

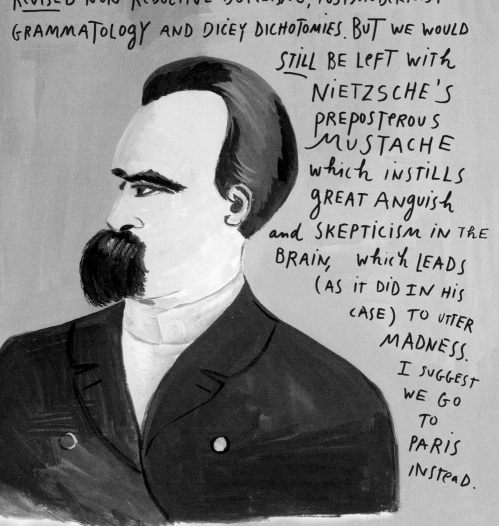

STILL BE LEFT WITH NIETZSCHE'S PREPOSTEROUS MUSTACHE which INSTILLS GREAT ANGUISH and SKEPTICISM IN THE BRAIN, which LEADS (AS IT DID IN HIS CASE) TO UTTER MADNESS. I SUGGEST WE GO TO PARIS INSTEAD.

PARIS

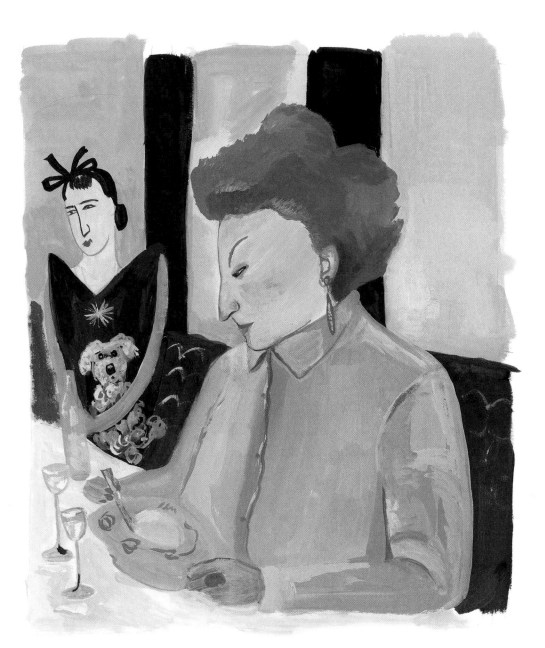

The WOMAN.

The dessert of floating islands.

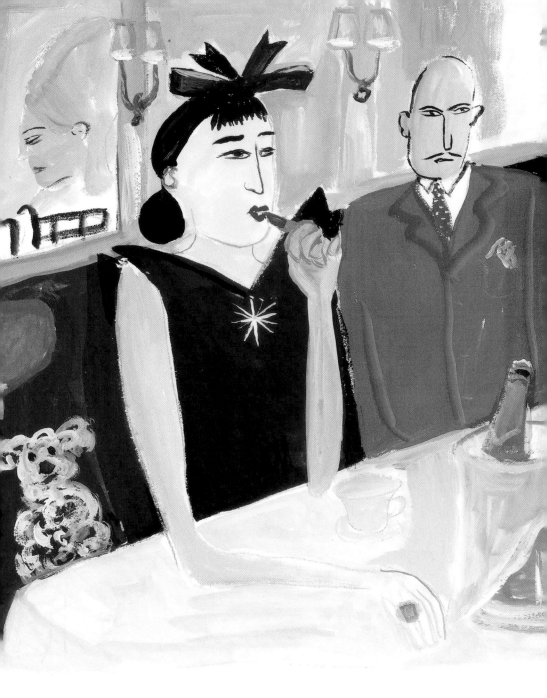

The application of Lipstick.

The first superlative Tassel.

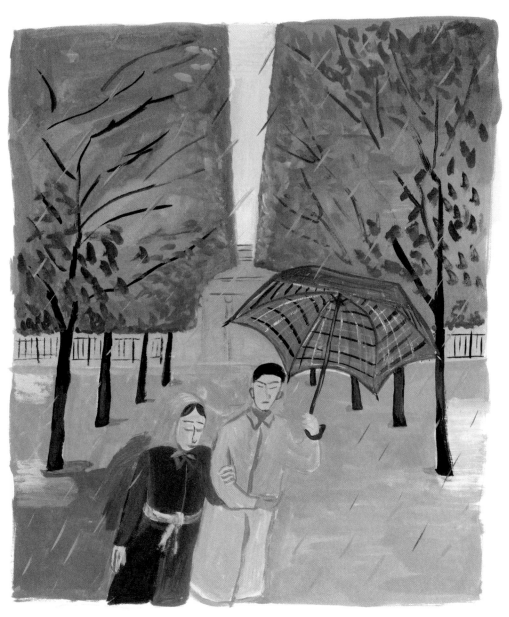

The Rain.

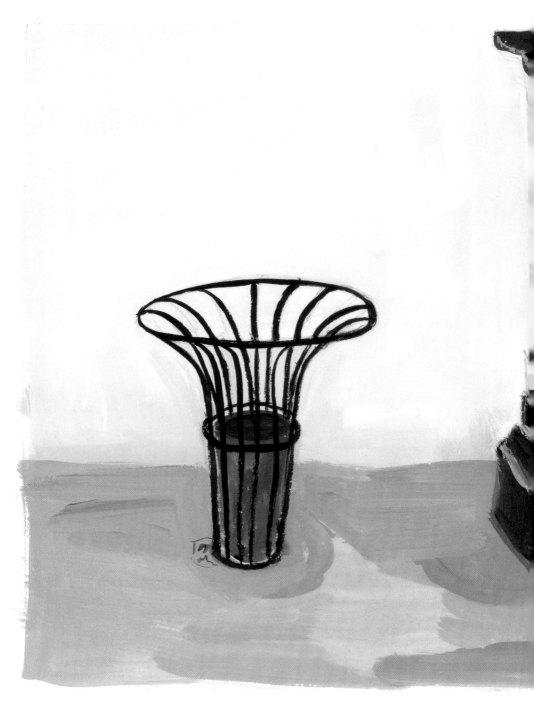

The gaRBage CANS.

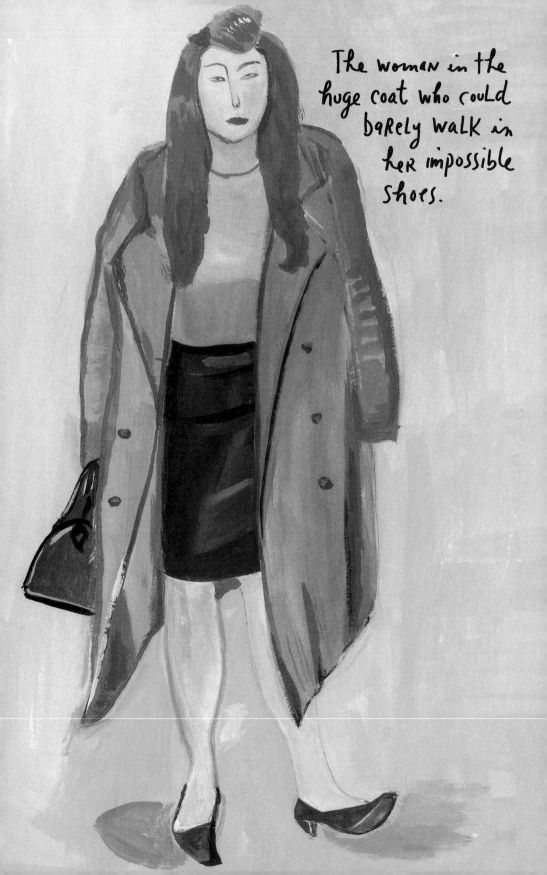

The woman in the
huge coat who could
barely walk in
her impossible
shoes.

The visit to the DEYROLLES shop.

The purchase of the Malaysian walking stick.

The wrapping of the parcel.

The PINK Bed.

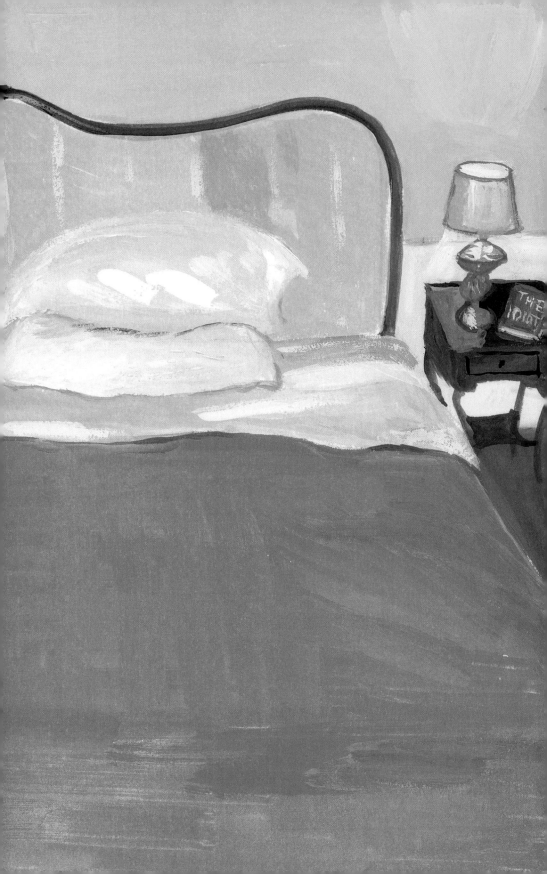

The Good Dream

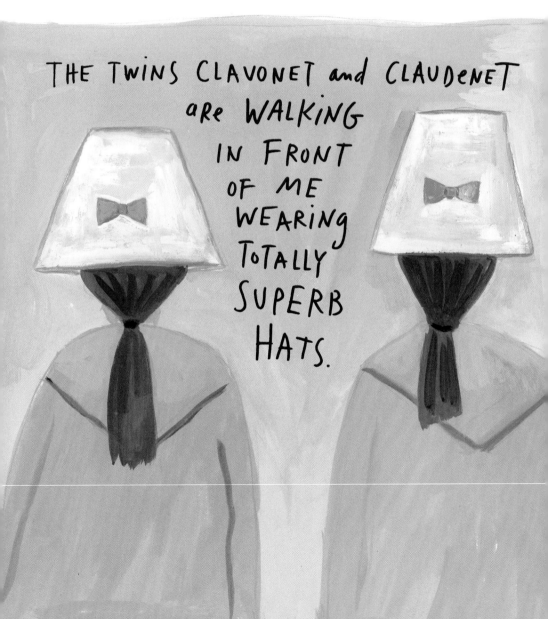

THE TWINS CLAVONET and CLAUDENET are WALKING IN FRONT OF ME WEARING TOTALLY SUPERB HATS.

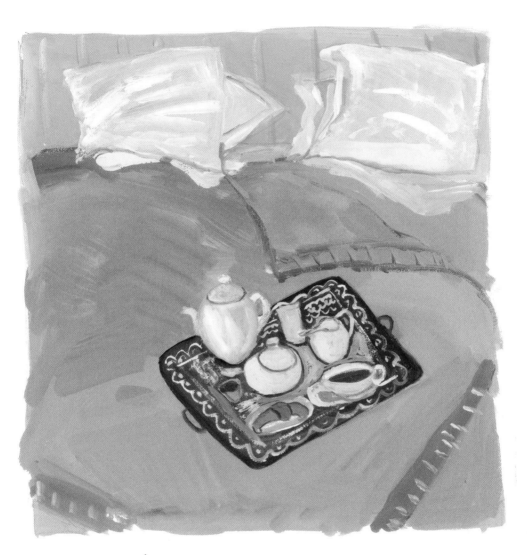

The celebratory wake-up Room Service.

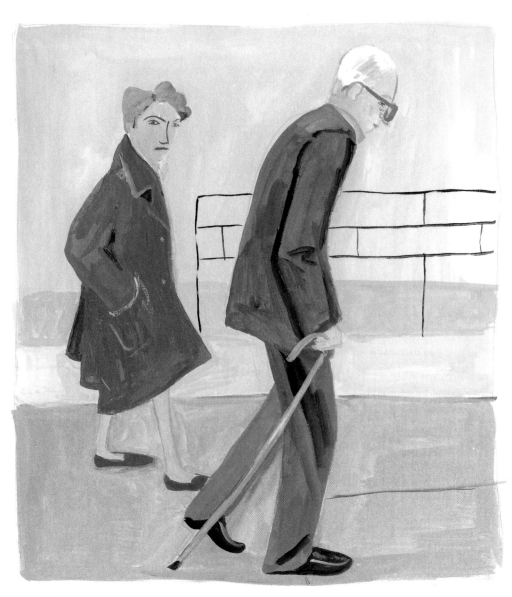

the couple.

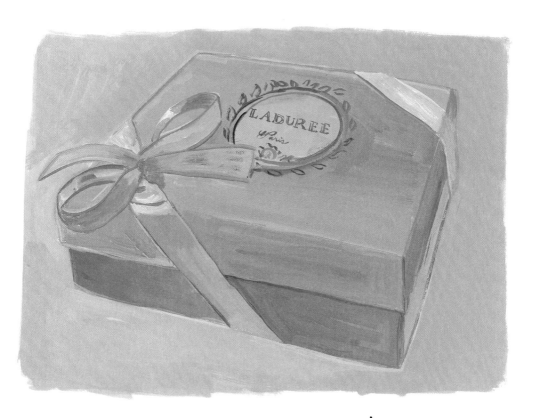

The Box of chocolates.

The side trip to Normandy
at the Hotel Flaubert
with the man in the Room
with a second
superlative tassel.

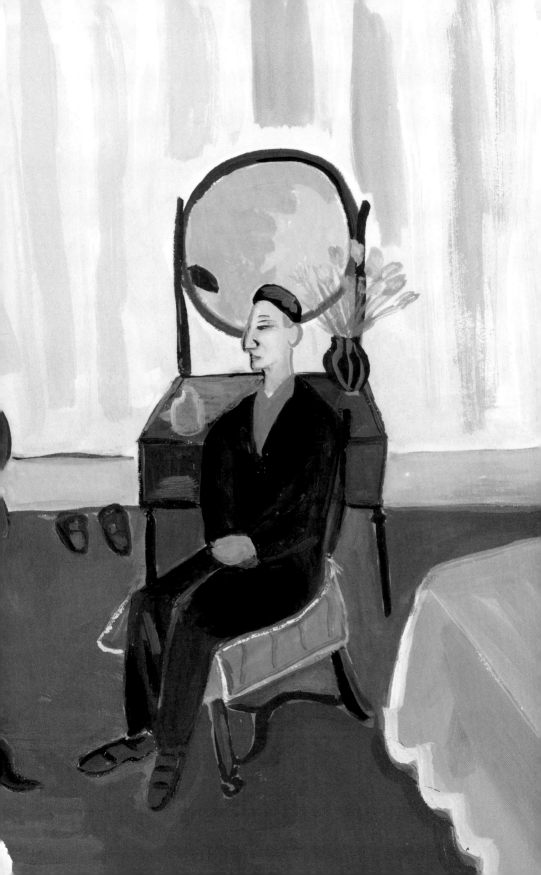

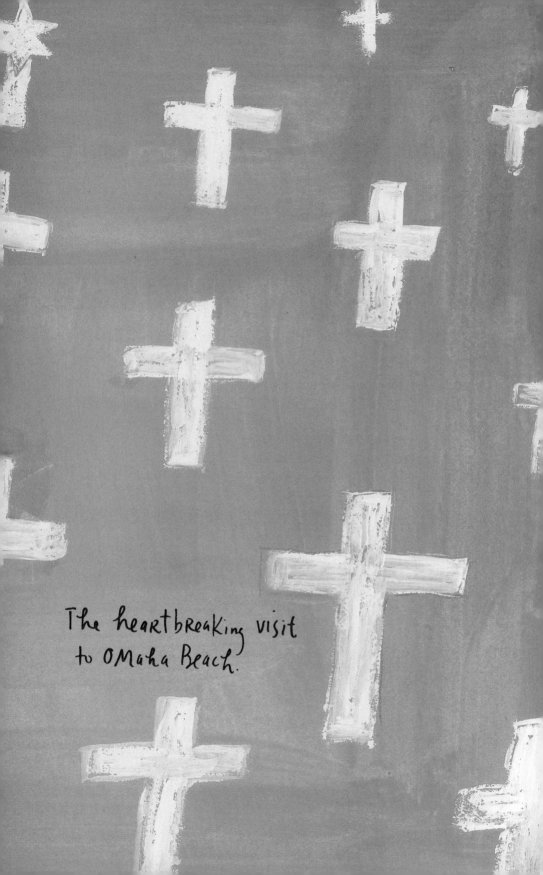

The heartbreaking visit
to Omaha Beach.

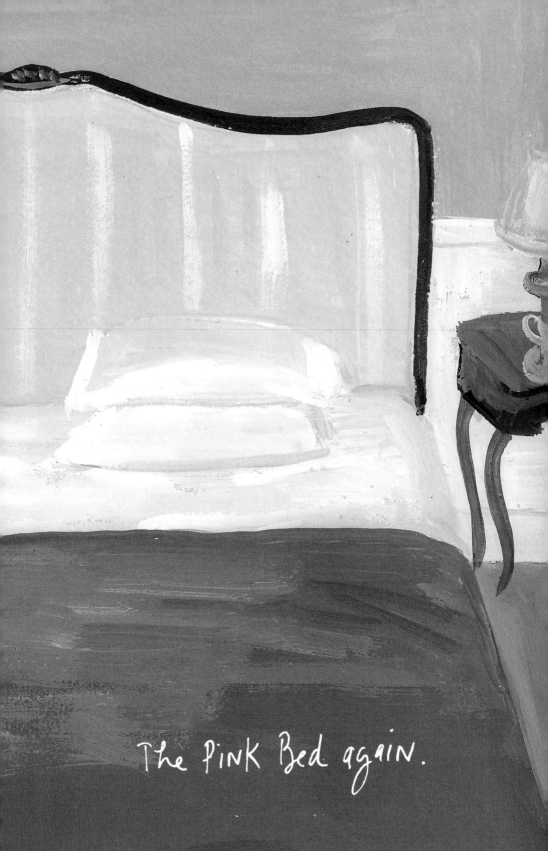

The PiNK Bed again.

THe BAD DREAM.

A WILD
POODLE
BEAST
BITES
MY ARM
AND
WON'T
LET
GO.

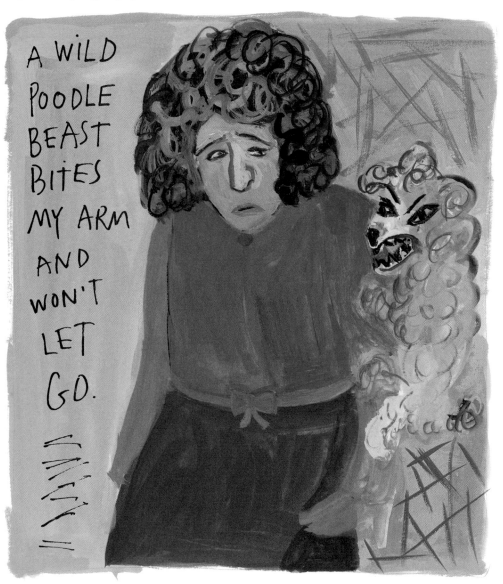

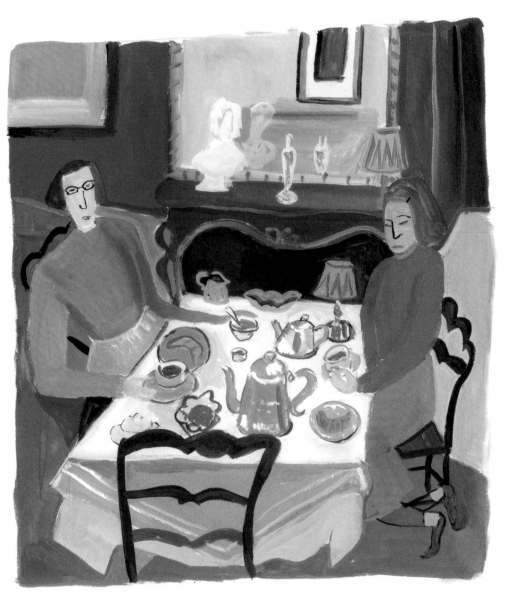

The breakfast with the Lingering Bad Dream Malaise.

The Beautiful girl with the pink RIBBON standing
Near me in the Luxembourg gardens, while
I sit in the grips of the MaLaise. But Less.

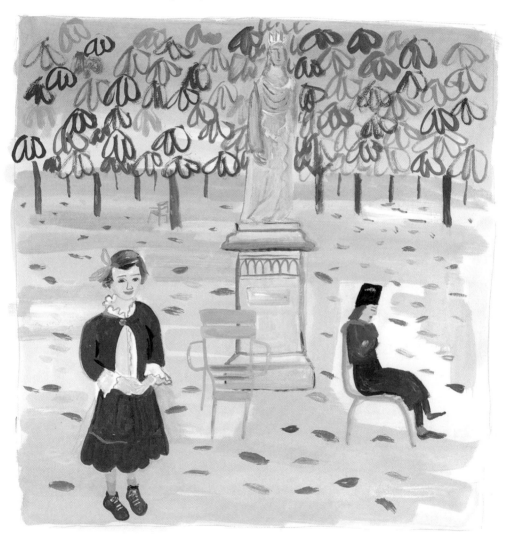

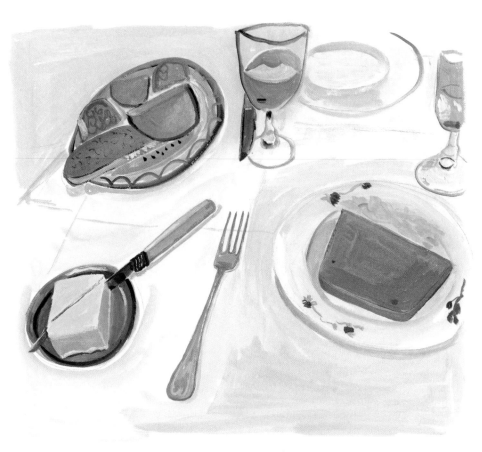

The pinky pink paté that totally wipes out the
Last vestige of malaise.

The silent sink in the Corbusier house that speaks the truth.

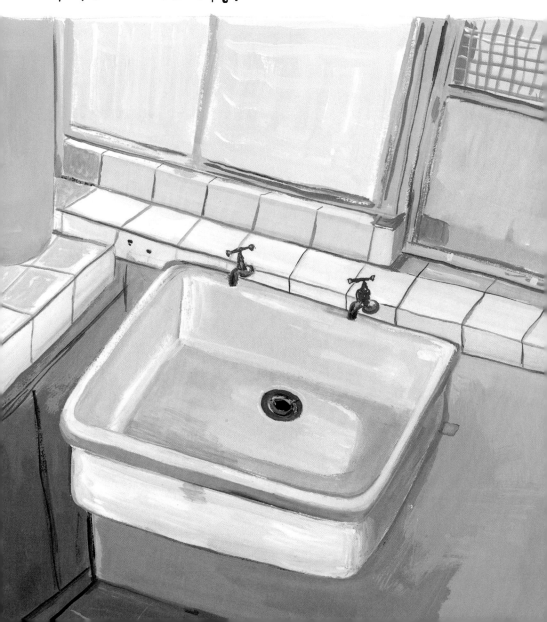

The ottoman on the way to the Proust Room.

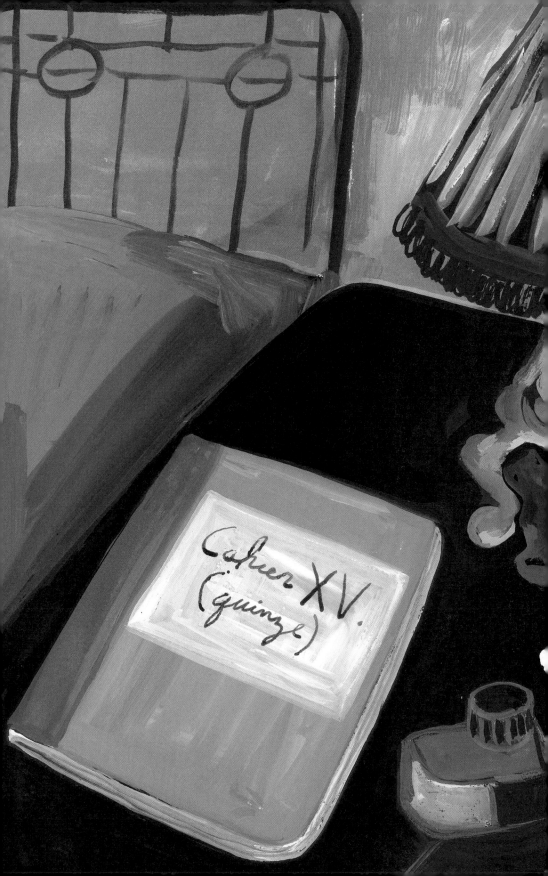

The PRoust notebook in the PRoust Room.

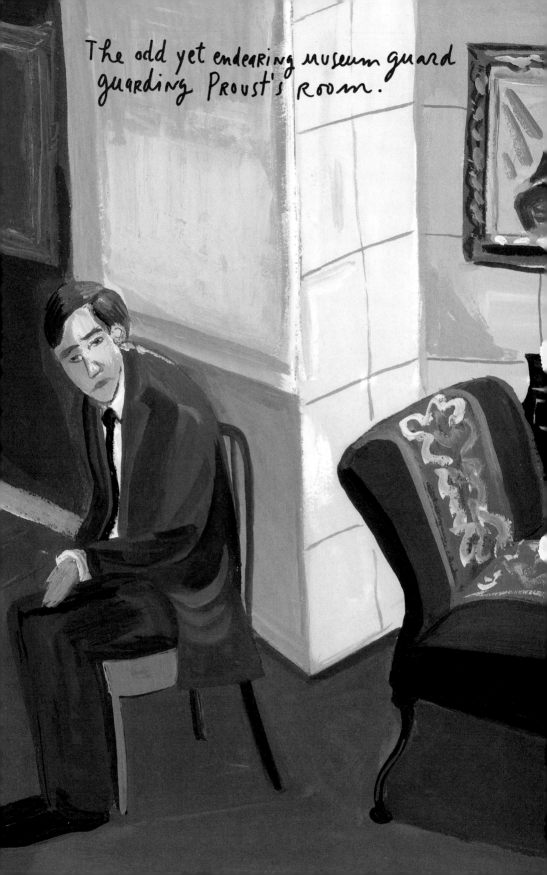

The odd yet endearing museum guard guarding Proust's room.

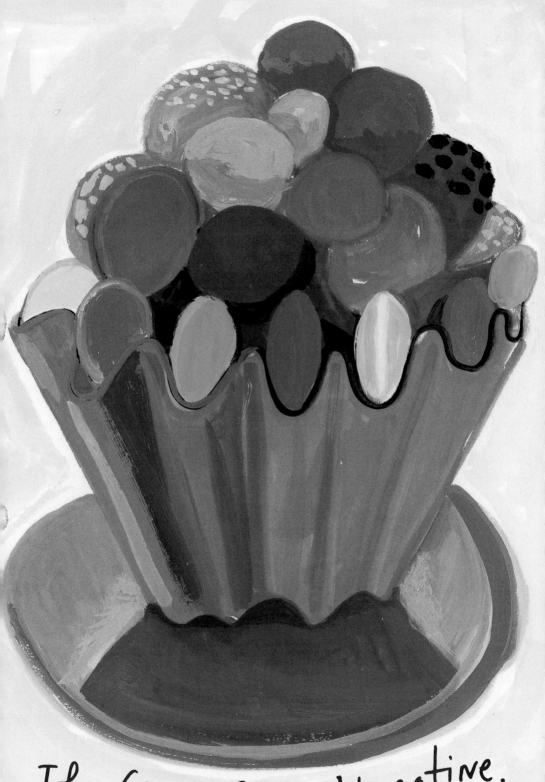

The Croque Choux Nougatine.

The discarded sofa on the street preparing me for my RETURN home.

The woman in St. Sulpice
lighting a candle next to me
Lighting a candle for my Mother.

The Return
to New York.
Oh Mama.
It's all
GOOD.

DECEMBER 6, 2006

•

After a chilly start, freshening winds will
deliver milder air.

Ich Habe Genug

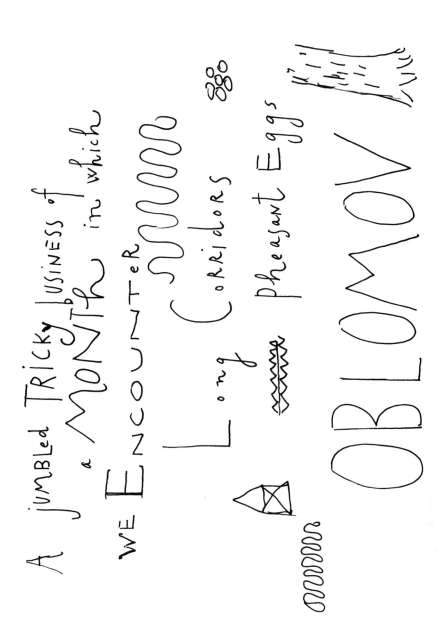

A jumBled TRicky BusinEss of a MONTH in which wE EncounteR Long CoRRidoRS Pheasant Eggs OBLOMOV

A GIRL with
a FUZZY
pink
COAT

FORTUNE
Tellers

Canasta Players

Thelma

Adolled Egyp
An Addlepated Man
ADALBERT VON CHAMISSO

Lime JeLLo

GLORIOUS WOMEN.

MARCEL DUChamP.

Lemon
Pound
Cake.

HoLY Mackerels.

NAPoLeon
iN EGYPT.

Strangers WHo are WiLLing To ANSWer
QUESTIONS

MUSIC.

A Quote By
Bertrand Russell

"ALL the LaBoR of ALL the Ages,
ALL the DEVOTION, all the INSPIRaTION.

aLL The Noonday brightness

of Human genius,

aRe destined to EXTinctioN..."

So Now, my Friends, if that is trvē
and it IS true, what is the POiNT?

A complicated question.

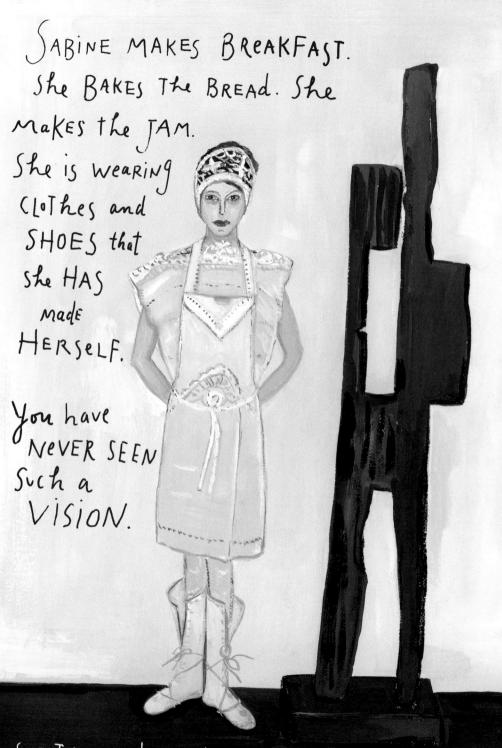

SABINE MAKES BREAKFAST.
She BAKES The BREAD. She
makes the JAM.
She is wearing
clothes and
SHOES that
she HAS
made
HERSELF.

You have
NEVER SEEN
Such a
VISION.

SHE TELLS me to READ "BUTTERBALL" by Maupassant.
I WILL.

SABINE

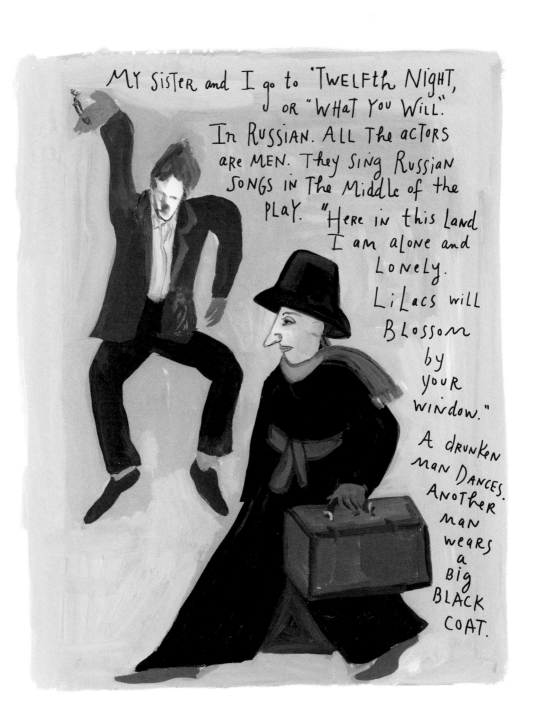

MY SISTER and I go to "TWELFTH NIGHT, OR "WHAT YOU WILL". IN RUSSIAN. ALL THE ACTORS ARE MEN. THEY SING RUSSIAN SONGS IN THE MIDDLE OF THE PLAY. "HERE IN THIS LAND I AM ALONE AND LONELY. LiLacs will BLOSSOM by YOUR WiNDOW." A drunken MAN DANCES. ANOTHER MAN WEARS a Big BLACK COAT.

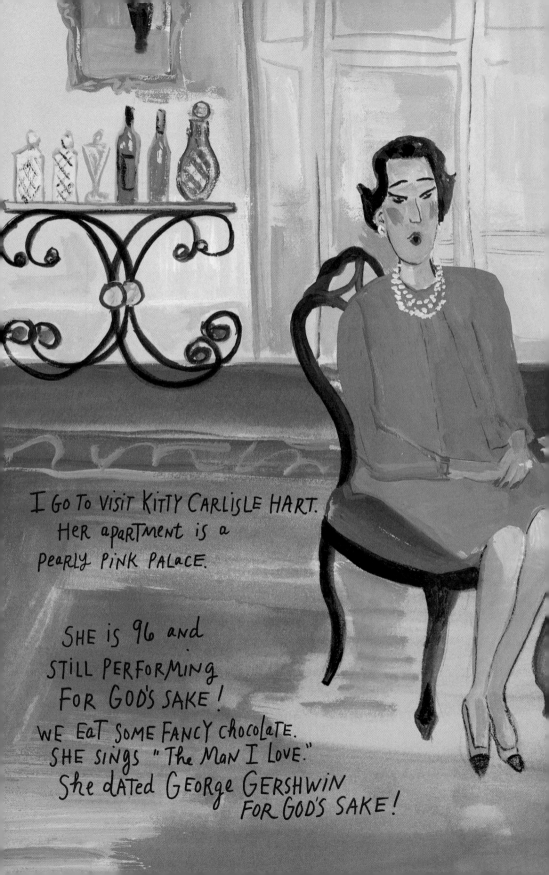

I GO TO VISIT KITTY CARLISLE HART.
 HER apartment is a
PEARLY PINK PALACE.

 SHE is 96 and
 STILL PERFORMING
 FOR GOD'S SAKE!
WE EAT SOME FANCY CHOCOLATE.
SHE SINGS "The Man I Love."
 She dated GEORGE GERSHWIN
 FOR GOD'S SAKE!

GERSHWIN DIED at The Age OF 38 OF a BRAIN TUMOR.

HE IS BURIED IN THE SAME CEMETERY AS MY HUSBAND.

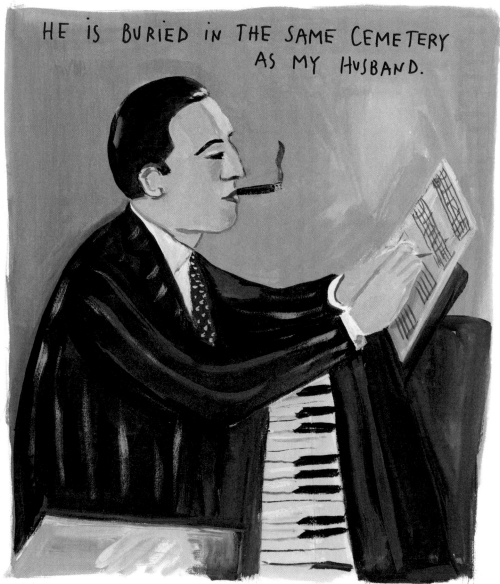

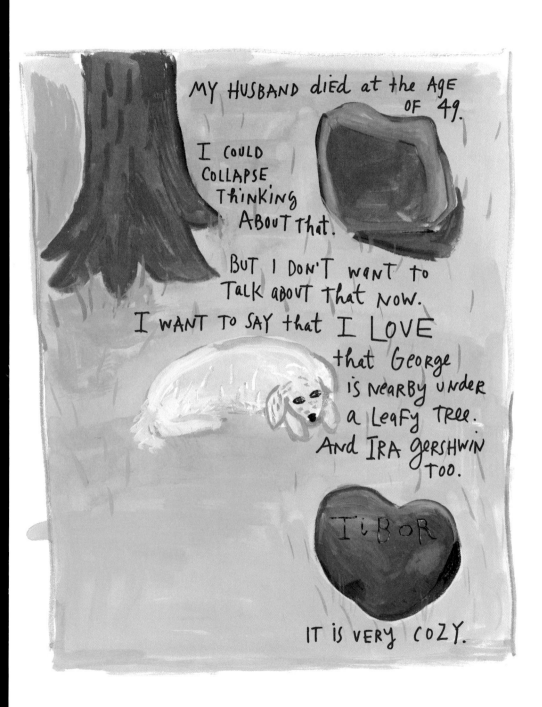

MY HUSBAND died at the AGE OF 49.

I COULD COLLAPSE Thinking ABOUT That.

BUT I DON'T WANT to TALK aBOUT That NOW.

I WANT To SAY that I LOVE that George is NEARBY UNDER a LeaFy TREE. AND IRA GERSHWIN TOO.

TIBOR

IT IS VERY COZY.

BUT The ABSOLUTE iCINg ON The
CEMETERY CAKE iS The BARRICINi FAMILY
MAUSOLEUM NEARBY.
I think the BARRICINi family should
OpeN a STORe There and SELL CHoCoLaTe.

I go To VISiT LOUISE BOURGEOIS.
SHE iS 96 AND STILL WORKS, FOR GoD'S SAKE!
HER STUDiO iS DiLApiDATED. DECAYiNg. iNSPIRING.
A YOUNG MAN READS a PoEM aBoUT LOVE.
IT iS HER SALON AFTeR ALL.
WE EAT PLAiN CHOCOLaTE.
SHE SiTS UNDER a RED BLANKET.

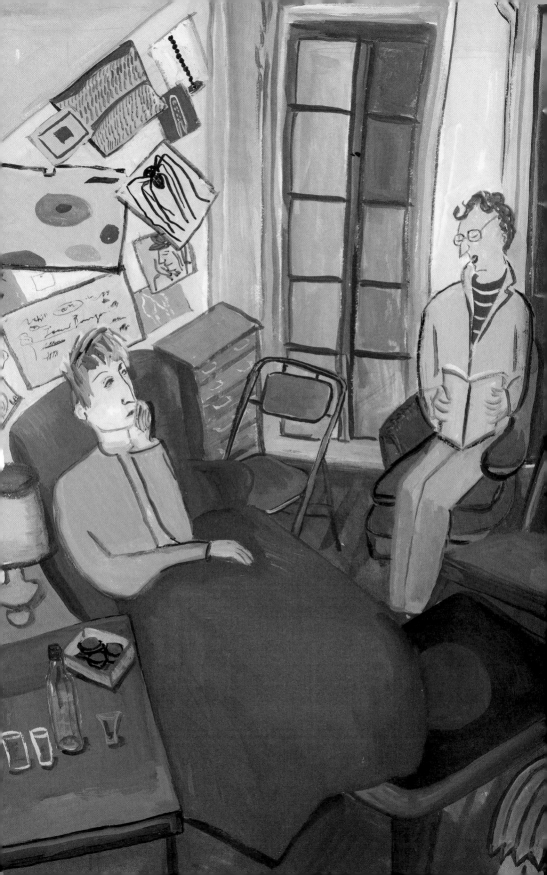

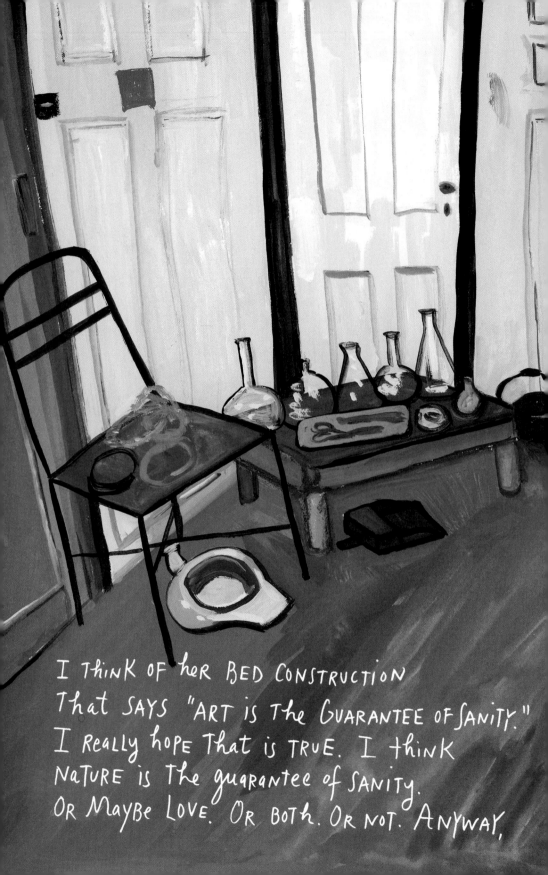

I THINK OF her BED CONSTRUCTION
That SAYS "ART IS The GUARANTEE OF SANITY."
I REALLY hope That IS TRUE. I think
NATURE IS The guarantee OF SANITY.
OR MaYBe LOVE. OR BOTH. OR NOT. ANYWAY,

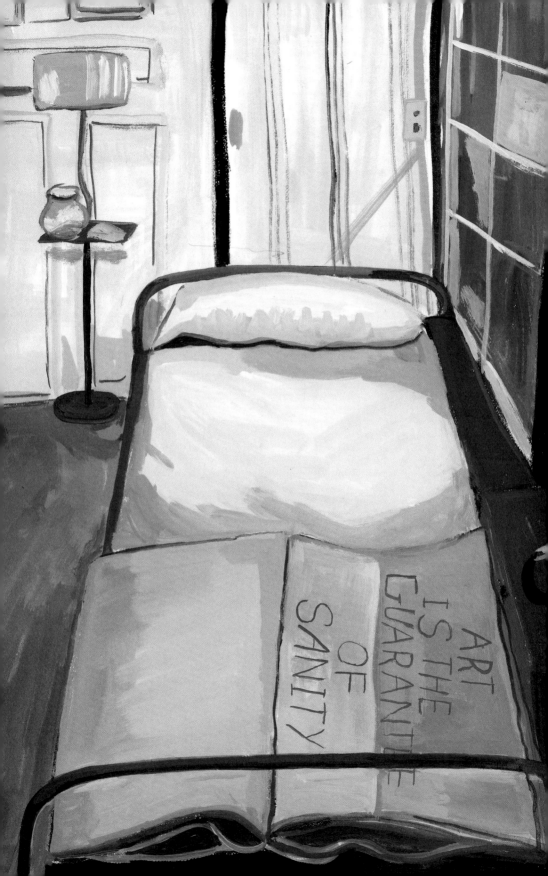

I look at her sink.

And leave.

On the street I photograph a Flowery Sofa.

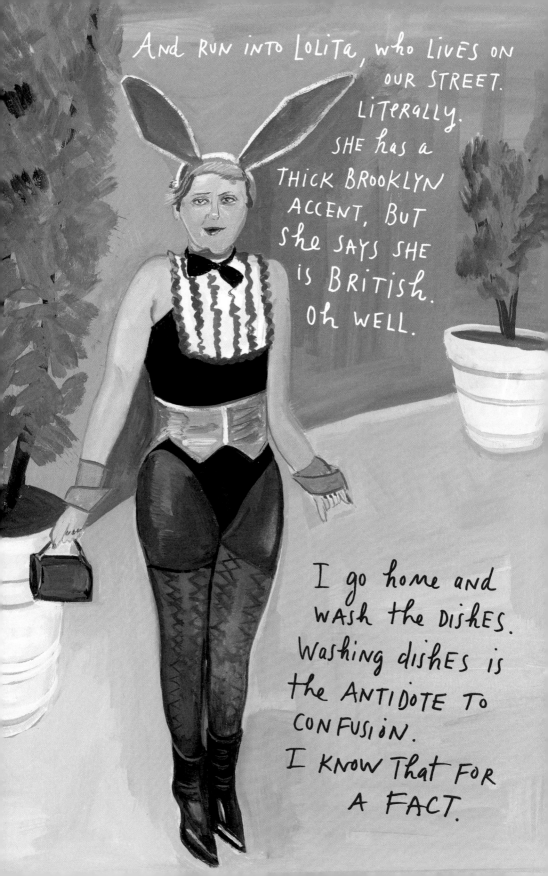

Carmen, Isaac and I have Tea.

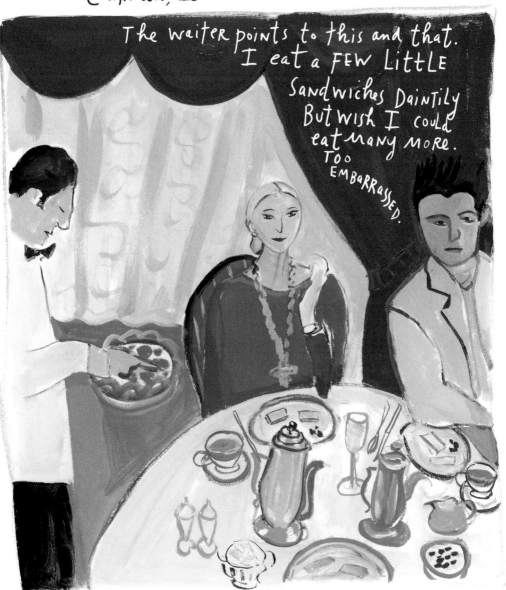

The waiter points to this and that. I eat a FEW LITTLE sandwiches Daintily But wish I could eat many more. TOO EMBARRASSED.

AUNT FRANCES DIED LAST WEEK.
86 YEARS OLD. DAUGHTER OF MINNIE
and LOUIE. FRANCES FELL IN LOVE
with EDDIE LANE. A BRILLIANT
SONGWRITER and BUSINESSMAN, who
WAS IN a WHEELCHAIR. HER
PARENTS WENT NUTS. BUT she
didn't care. She married
him and lived a
CHARMED LIFE.

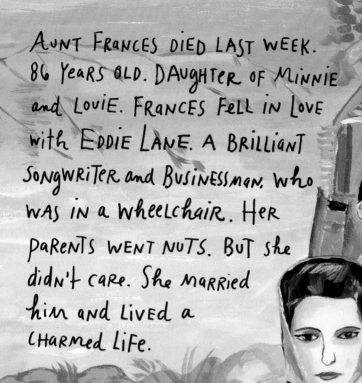

Near the end, with
ALZHEIMER'S, she
tried to pay a
patient CASHIER at
the BAGEL
BUFFET with
SWEET'N
LOW

packets.
CAREFULLY COUNTING them OUT. I LOVE that STORY.
What is the POINT?

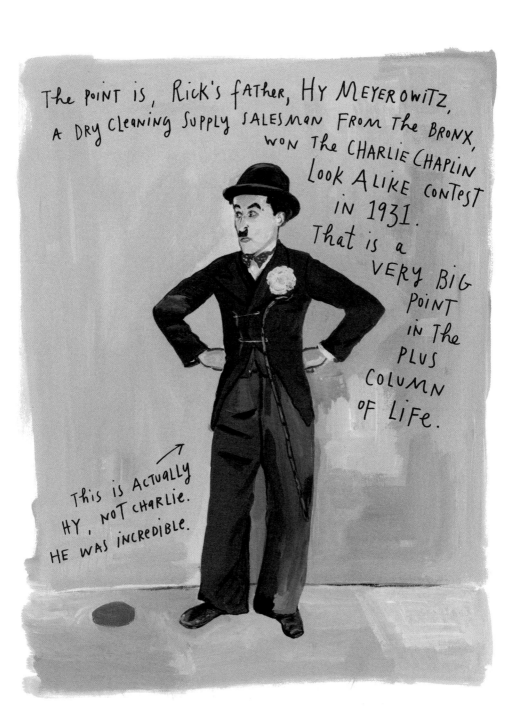

The POINT IS, Rick's father, HY MEYEROWITZ, A DRY Cleaning Supply SALESMAN FROM THE BRONX, WON THE CHARLIE CHAPLIN Look ALIKE CONTEST IN 1931. That is a VERY BIG POINT in THE PLUS COLUMN OF LIFE.

THIS is ACTUALLY HY, NOT CHARLIE. HE WAS INCREDIBLE.

I went to a FRIEND'S warm and EASygoing BiRthday PARty.

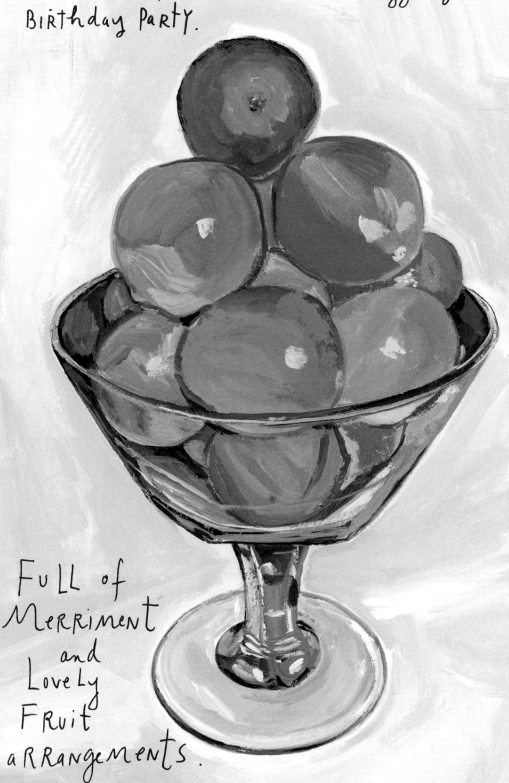

FULL of
MeRRiMent
and
LoveLy
FRuit
aRRangeMents.

ON the WALL WAS a DRESS That I EMBROIDERED.
It SAID "Ich HABE GENUG." Which is a BACH CANTATA.
Which I ONCE thought Meant "I'VE HAD IT, I CAN'T TAKE
anyMore, GIVE ME a BREAK." BUT I WAS WRONG.

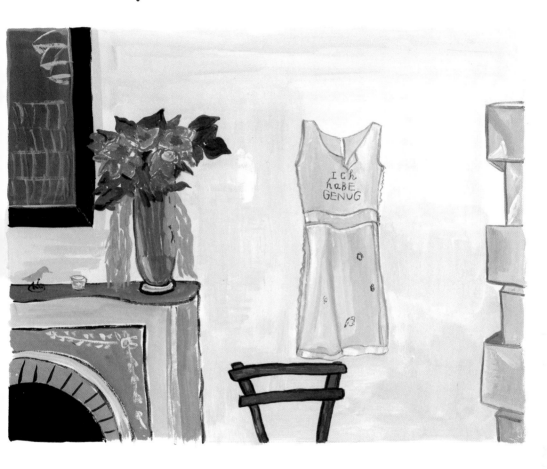

It MEANS "I HAVE ENough."
AND that is UTTERLY TRUE.
I happen To Be ALIVE. ENd of DISCUSSION.
BUT I WILL GO OUT and BUY a HAT.

JANUARY 3, 2007

●

Unusually mild weather.
Temperatures will be far above normal.

Completely

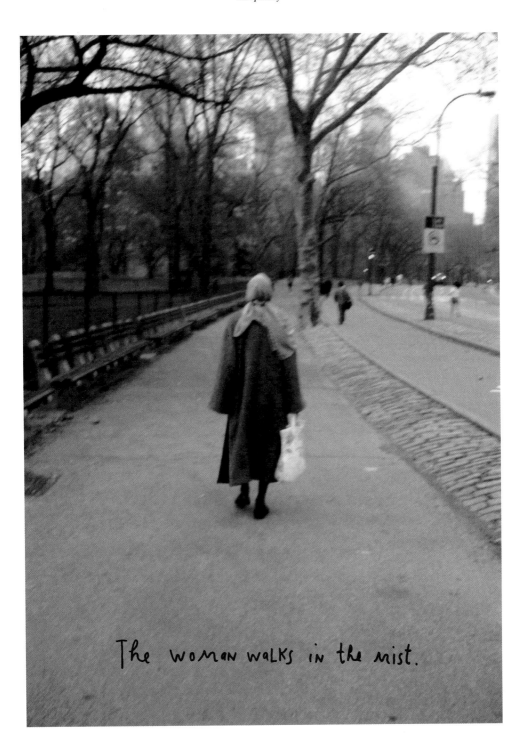

The woman walks in the mist.

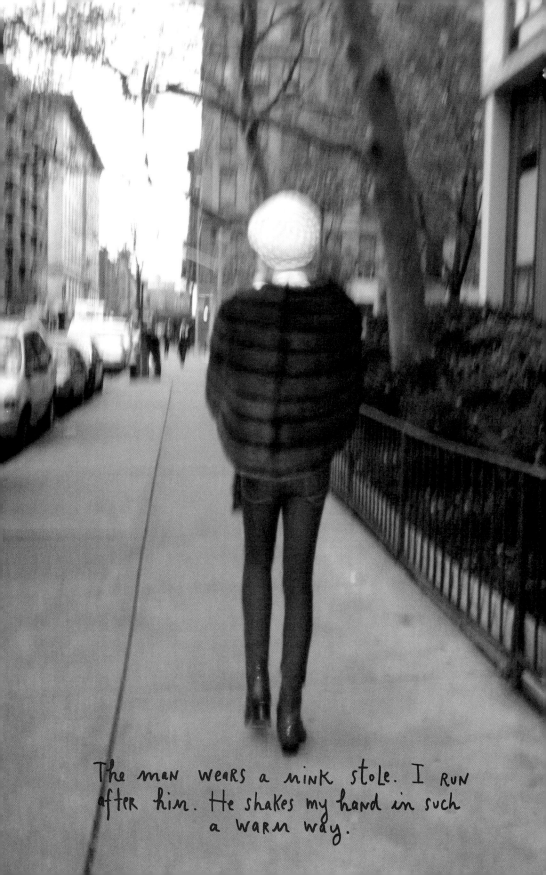

The man wears a mink stole. I run after him. He shakes my hand in such a warm way.

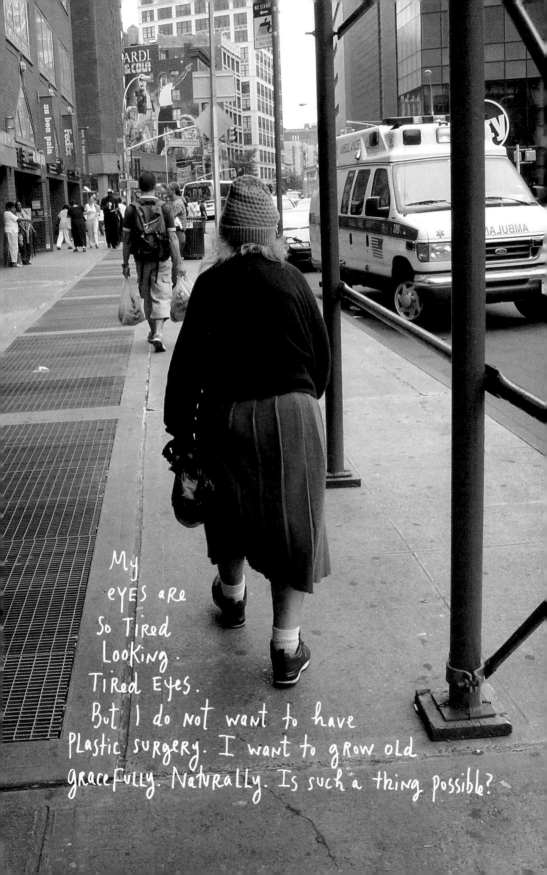

My
eyes are
so tired
looking.
Tired eyes.
But I do not want to have
plastic surgery. I want to grow old
gracefully. Naturally. Is such a thing possible?

Is such a thing possible?

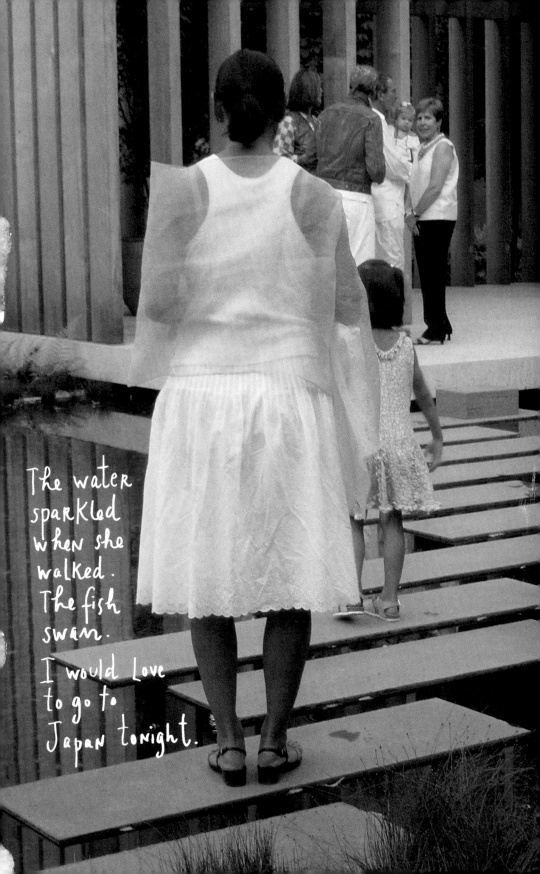

The water
sparkled
when she
walked.
The fish
swam.
I would love
to go to
Japan tonight.

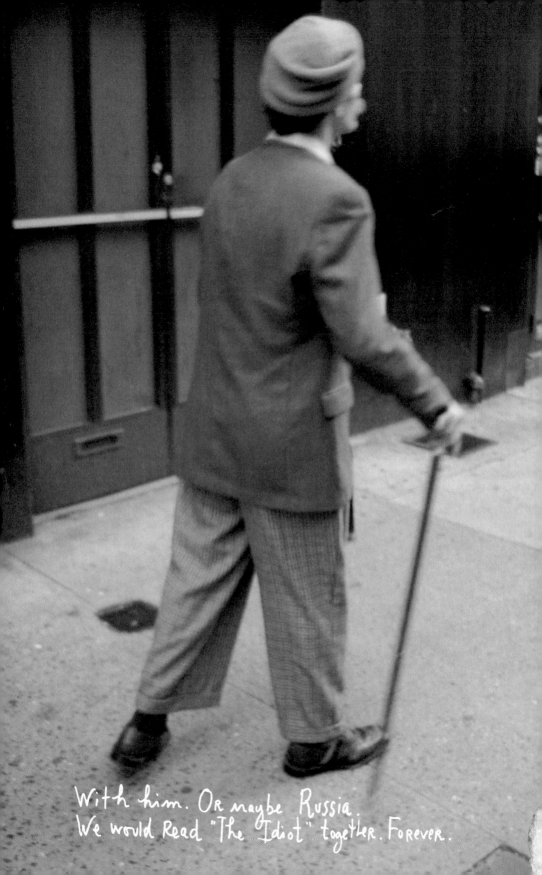

With him. Or maybe Russia.
We would Read "The Idiot" together. Forever.

In the Hermitage you would see this bow on this woman.

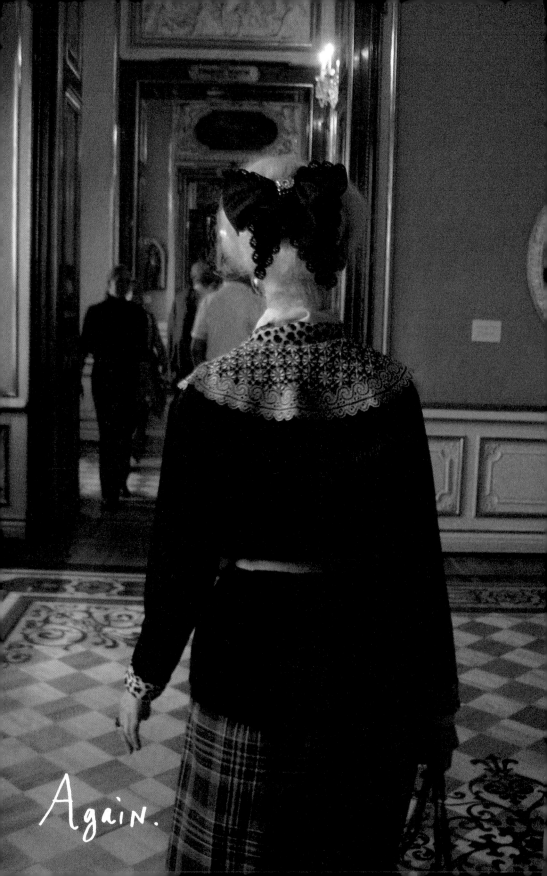

And again. And then
have tea or vodka.
You would be so
GRATEFUL
to
FoLLoW
her and
see that
Bow.

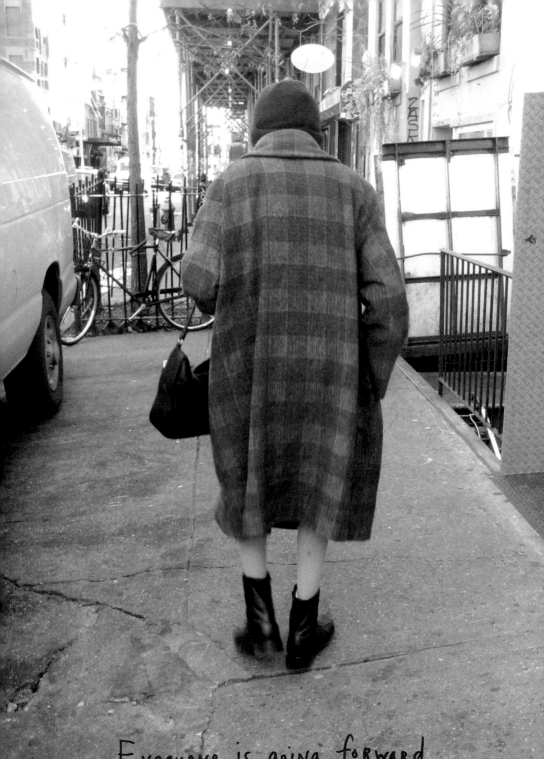

Everyone is going forward.

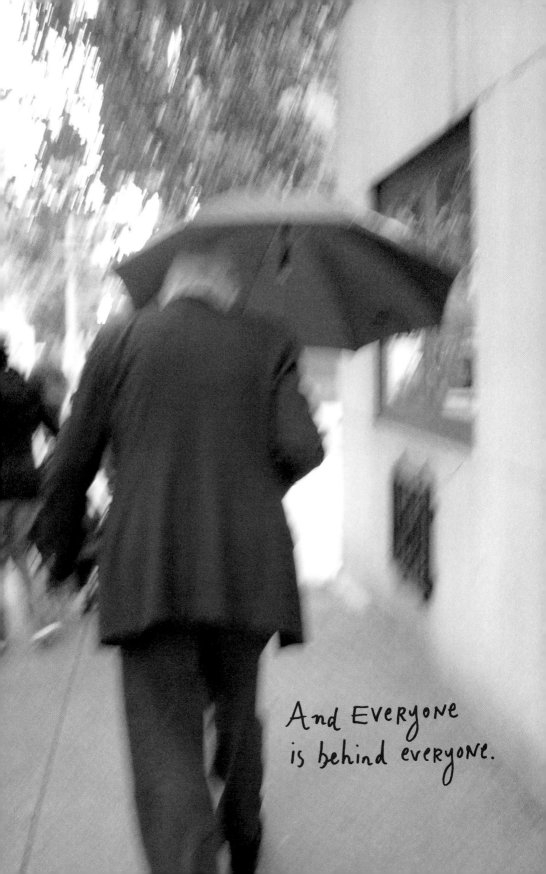

And EVERYONE
is behind everyone.

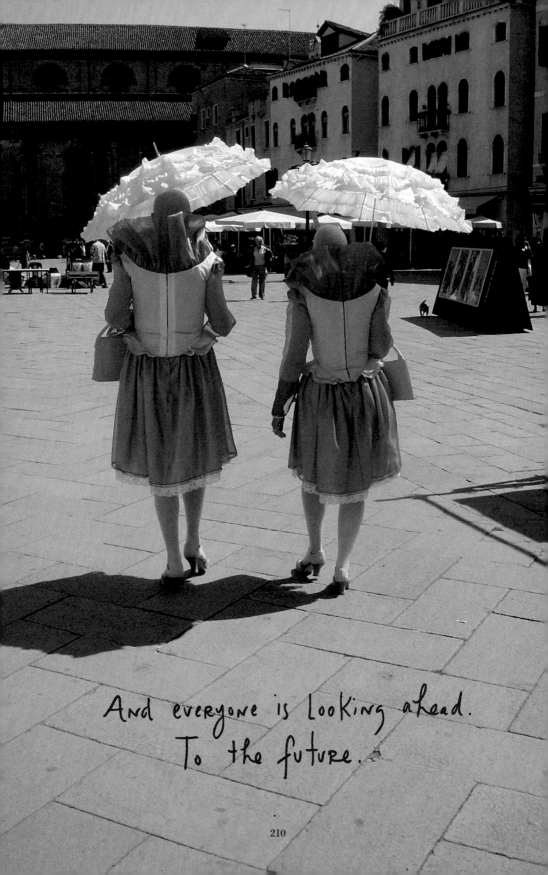

And everyone is looking ahead.
To the future.

And people walk together.
In step.

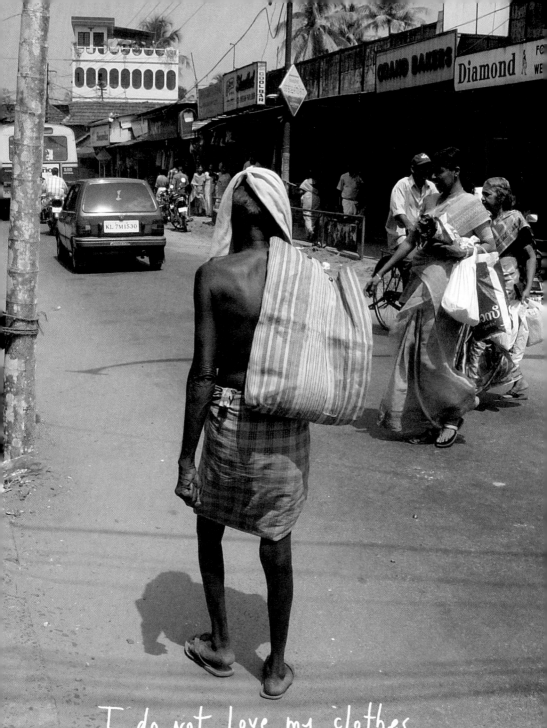

I do not love my clothes.
They are not right. I have
not found myself yet.

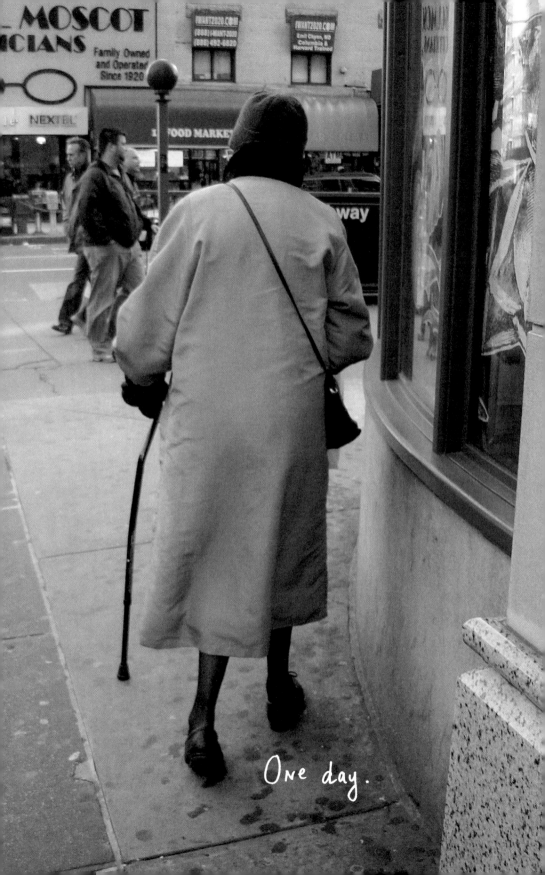

One day.

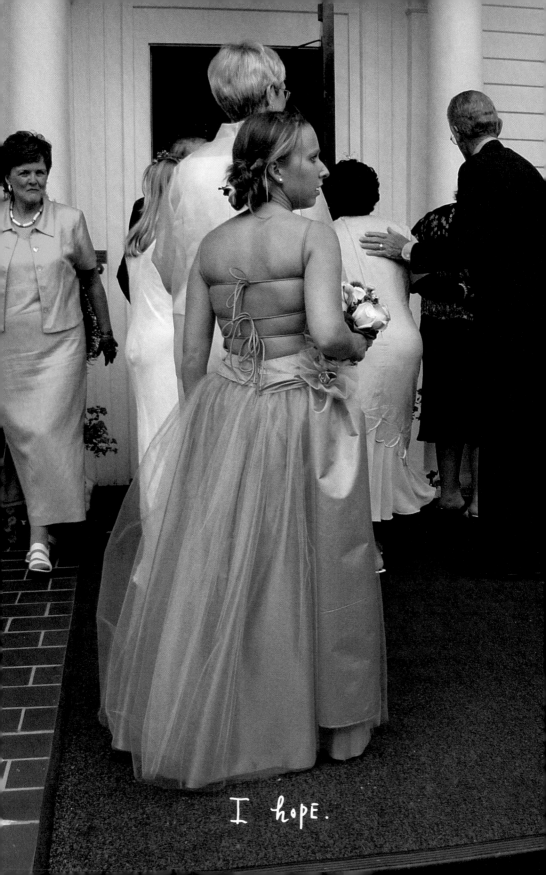

I hope.

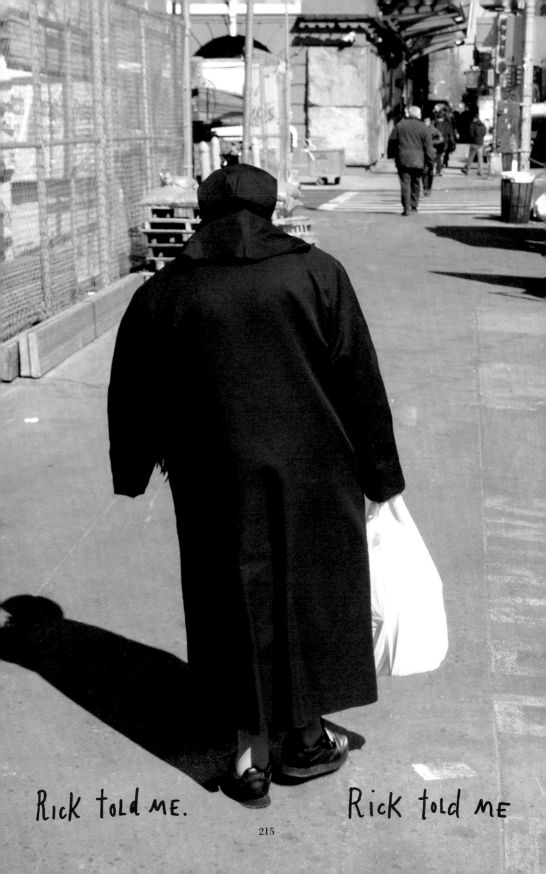

Rick told me.

Rick told me

THE SUN will EXPLODE
FIVE BILLION
YEARS FROM NOW.

SET
YOUR
WATCHES.

That Really
cHanges
EVERYTHing.
DOESN'T IT?

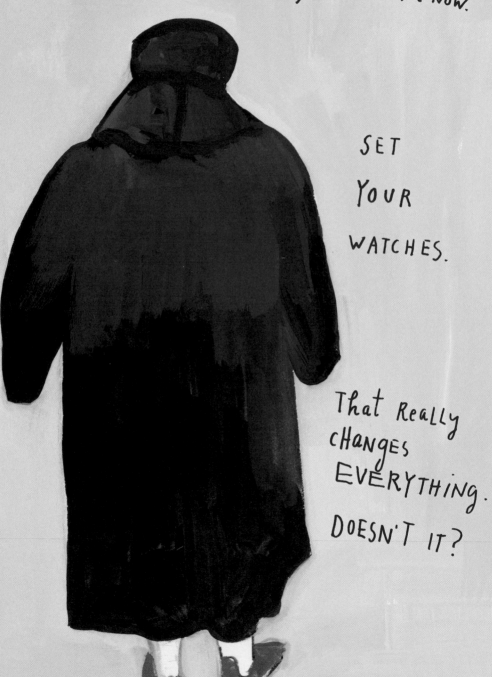

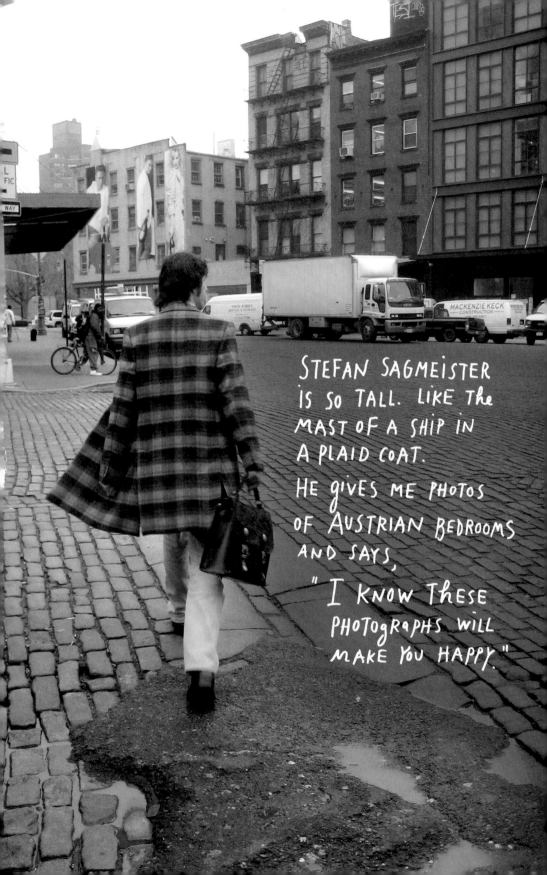

STEFAN SAGMEISTER
IS SO TALL. LIKE The
MAST OF A SHIP IN
A PLAID COAT.

HE GIVES ME PHOTOS
OF AUSTRIAN BEDROOMS
AND SAYS,

"I KNOW THESE
PHOTOGRAPHS WILL
MAKE YOU HAPPY."

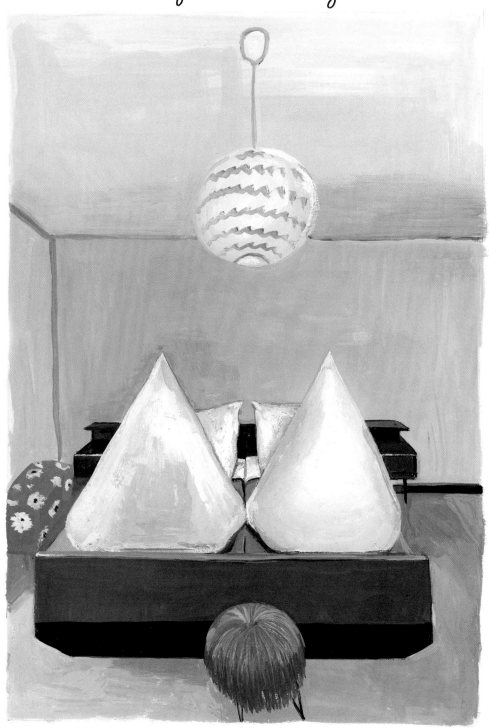

SCHLAFZIMMER WITH FOLDED QUILTS

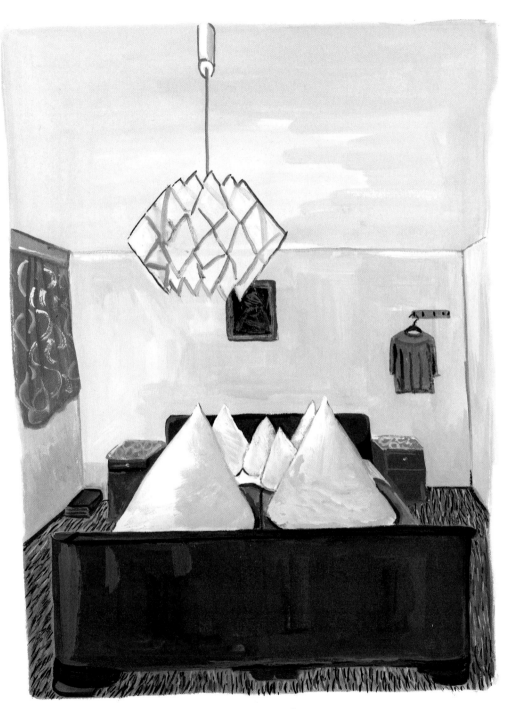

SCHLAFZIMMER WITH FOLDED QUILTS + PILLOWS

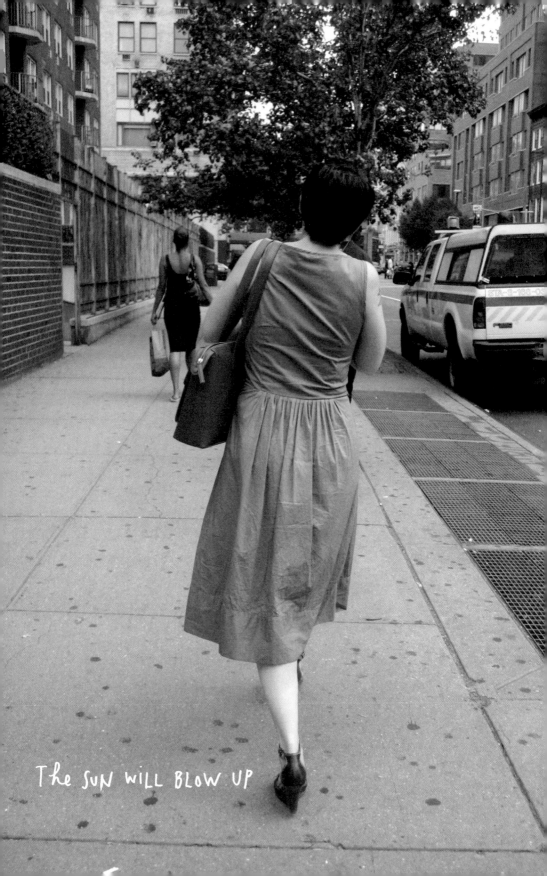

THE SUN WILL BLOW UP

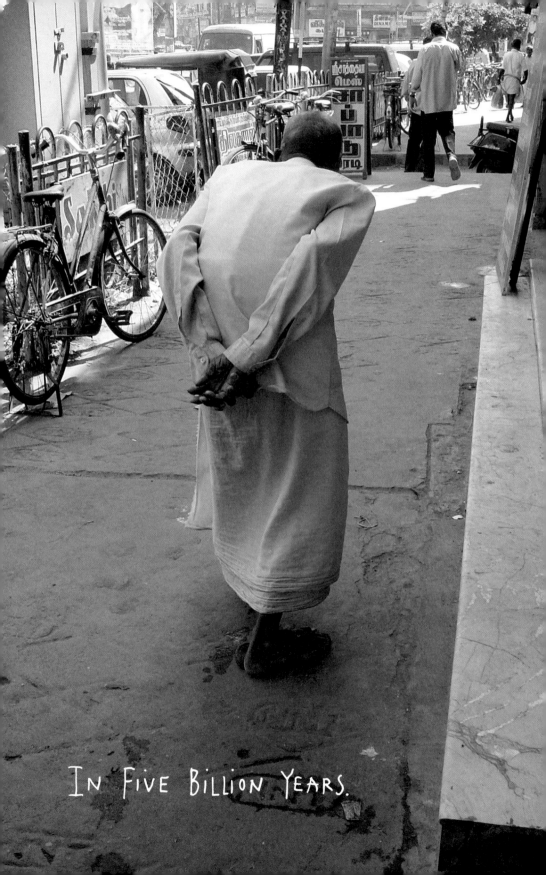

IN FIVE BILLION YEARS.

Knowing that,
How could anyone want a war.
Or plastic surgery. But I am
being naive. And the unknown
is so unknowable. And who
is to judge? Really.

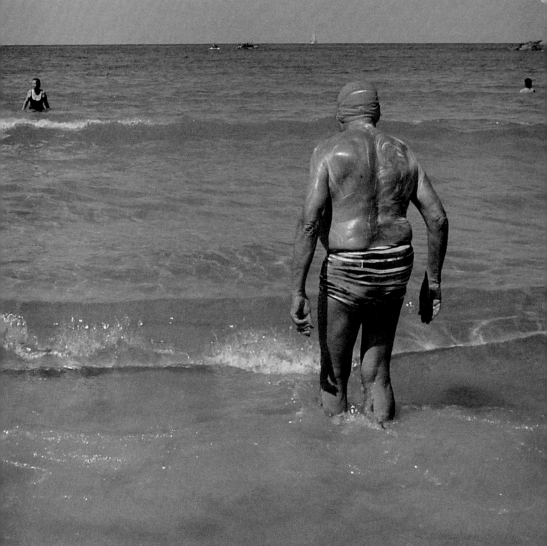

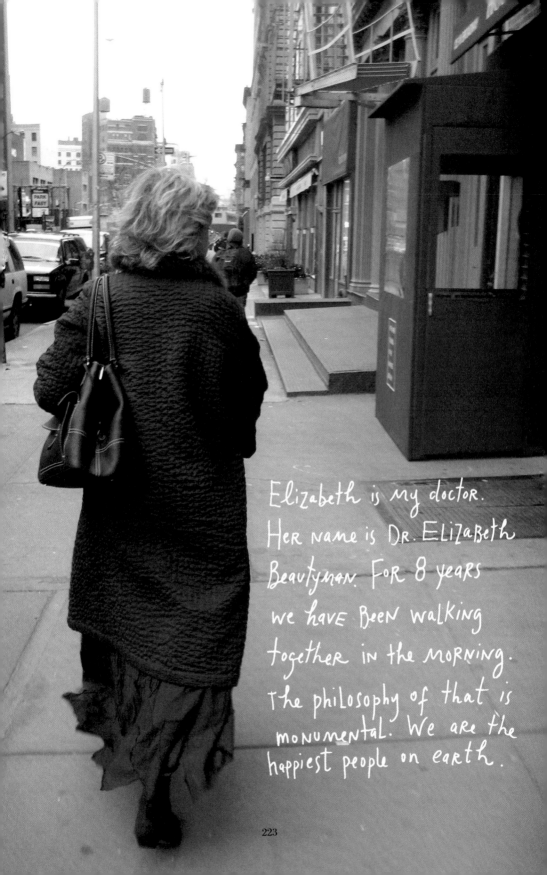

Elizabeth is my doctor.
Her name is Dr. Elizabeth
Beautyman. For 8 years
we have been walking
together in the morning.
The philosophy of that is
monumental. We are the
happiest people on earth.

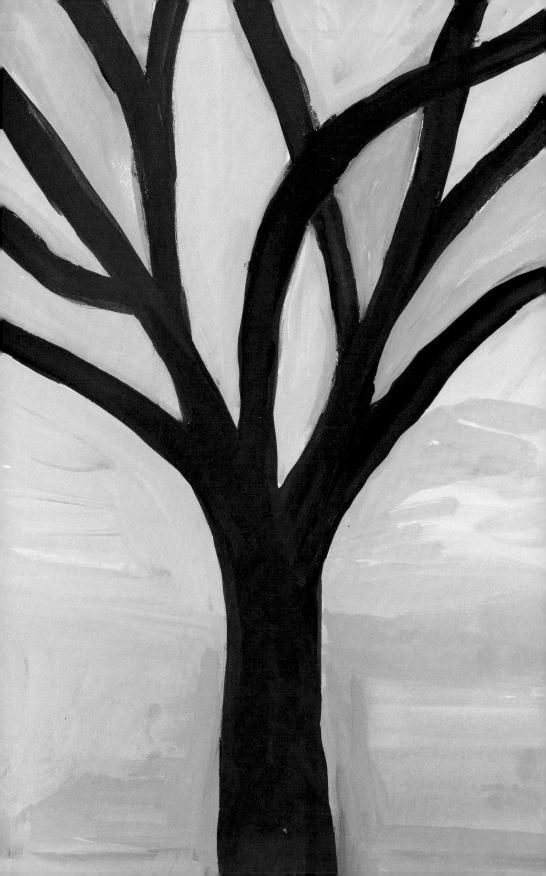

WE SEE TREES.

WHAT MORE DO
WE NEED?

There is so much to do.

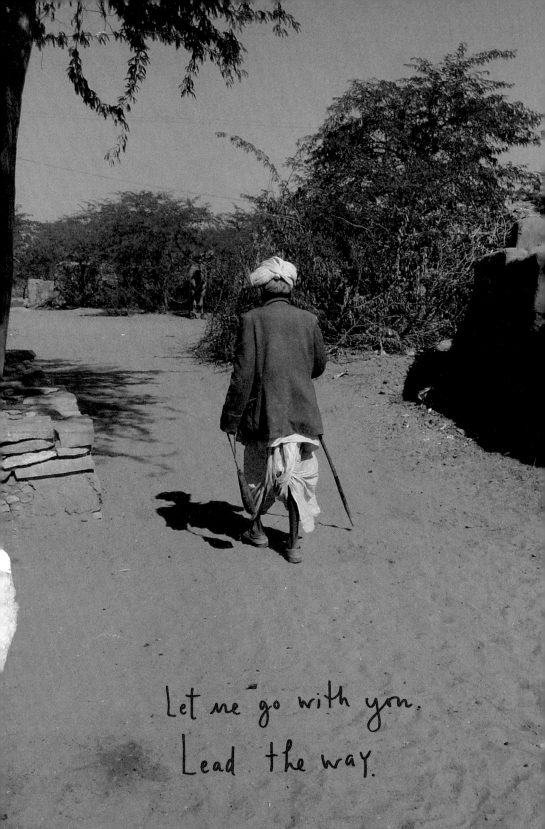

Let me go with you.
Lead the way.

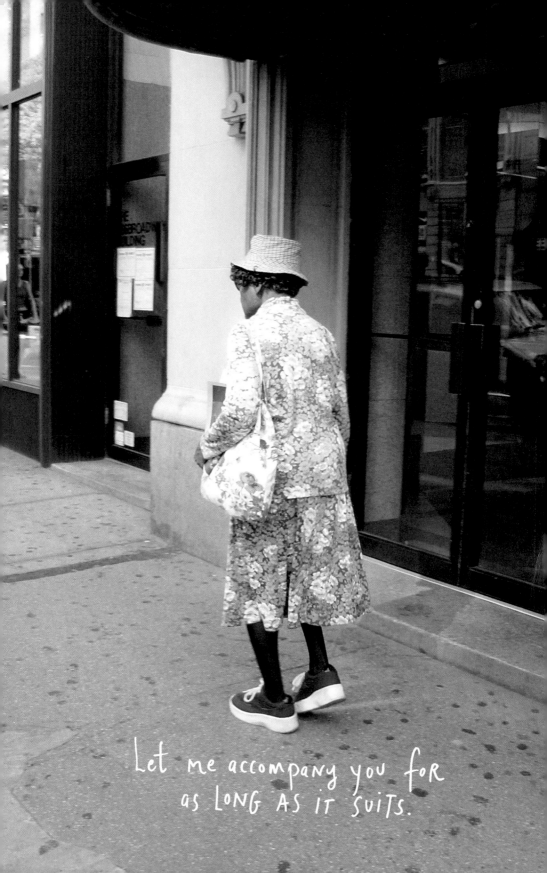

Let me accompany you for as long as it suits.

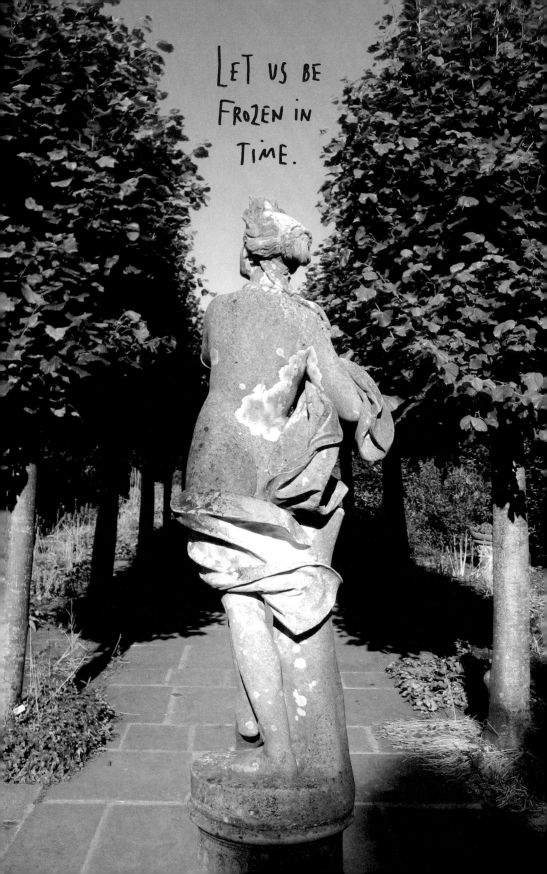

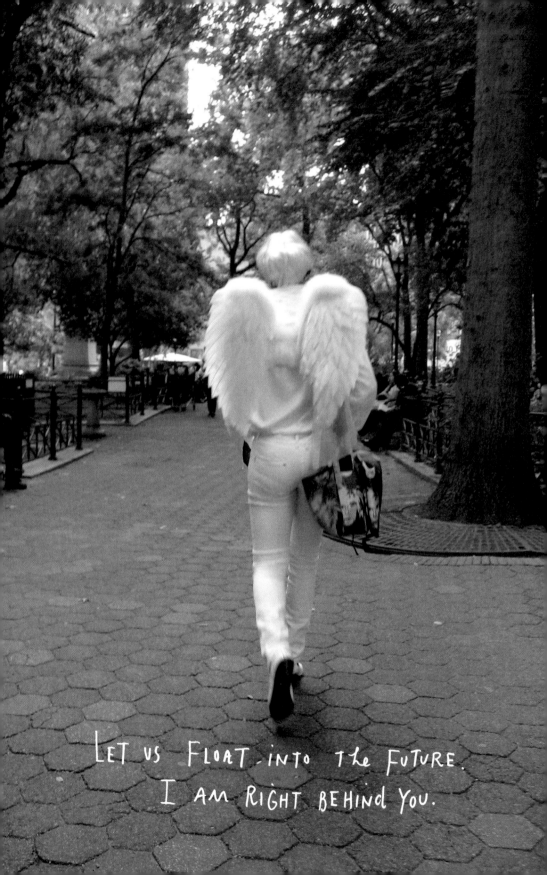

LET US FLOAT into the FUTURE.
I AM RIGHT BEHIND YOU.

BETWEEN NOW and FIVE BILLION years
FROM NOW, SOMEONE WILL LOOK OUT OF
THIS WINDOW.

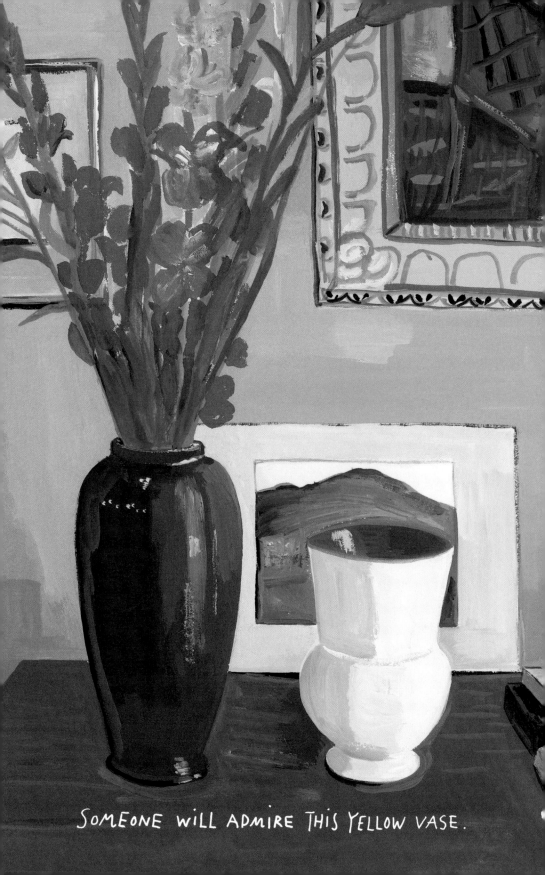

SOMEONE WILL ADMIRE THIS YELLOW VASE.

And someone will remember that I did buy a completely **Sensational Hat.**

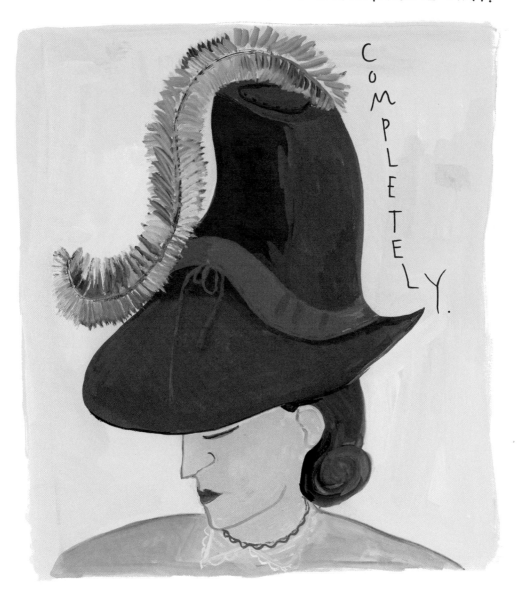

COMPLETELY.

FEBRUARY 7, 2007

•

Quite cold.

THE IMPOSSIBILITY
OF FEBRUARY

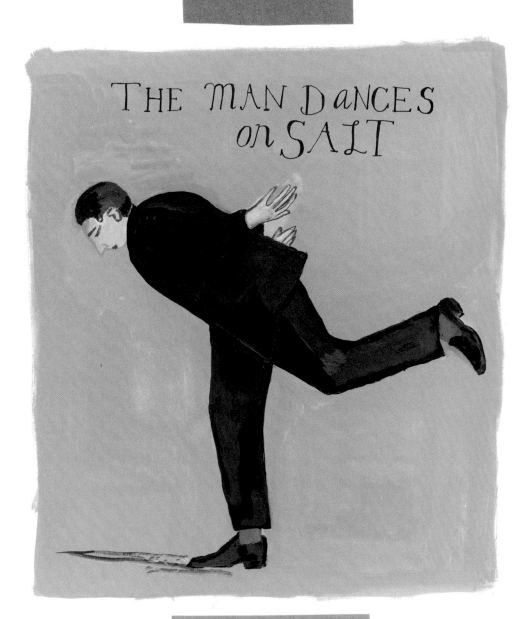

THE MAN DANCES
on SALT

The man dances on salt.

A package arrives wrapped in newspaper and tied
with strips of fabric.

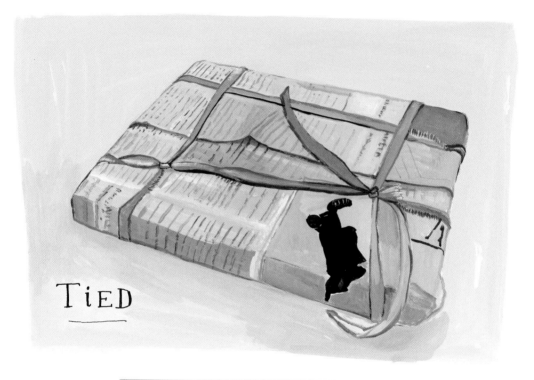

TiED

The newspaper has a photo of a man.
The man is lying in the snow dead.

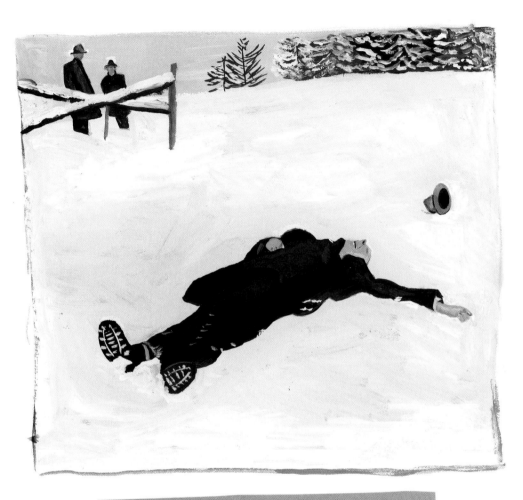

Here is the man.
His hat flew off his head.
I hope he is not really dead, just enjoying
 a refreshing lie-down in the snow.
 But the caption says he is dead.

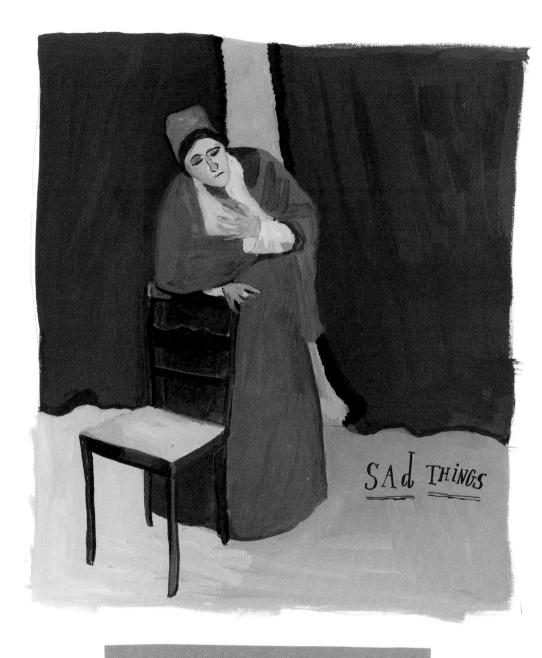

SAd THiNGs

The woman leans over in anguish. Not about
that man, but about all sad things.
It happens quite often in February.

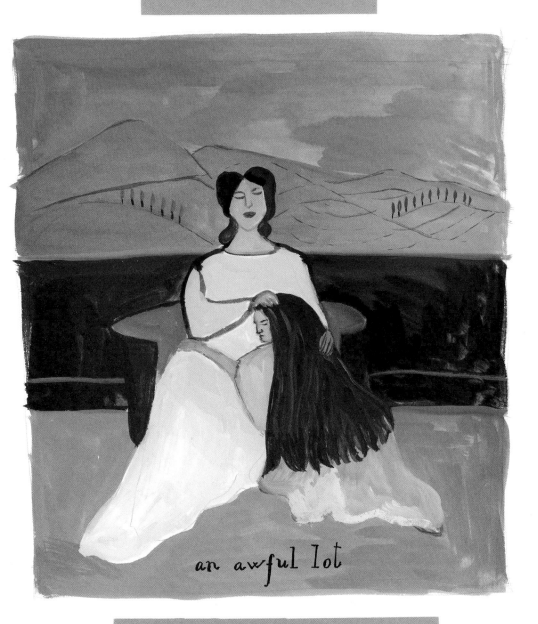

an awful lot

She sings a lullaby about angels watching
over the girl. You cannot help but notice
that that is an awful lot of hair to wash
and comb every day.
No matter.
Something to do.

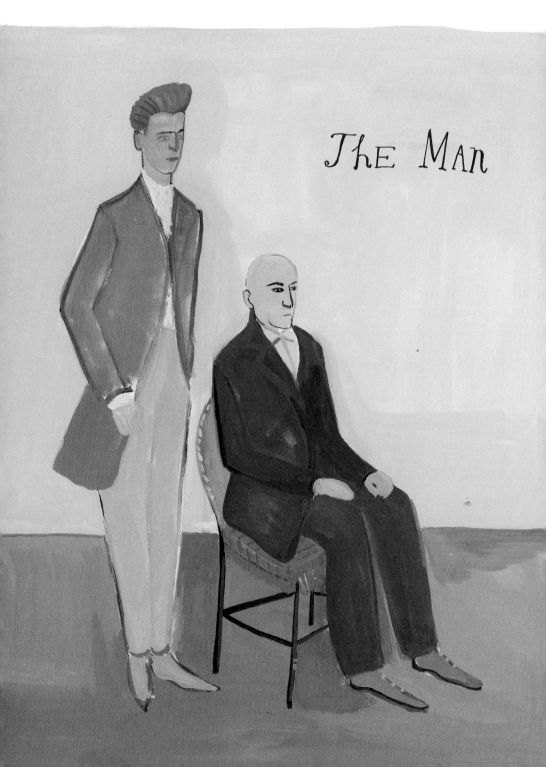

THE MAN

The seated man thinks,
"For heaven's sake, stop standing behind me.
You are driving me mad. It is freezing here.
It is February and it is impossible.
Someone has thrown onion skins all over the
stairwell. Now I will have to clean them up-
though I love to sweep. But still, it
is disgusting."
But all he says is "I have to go soon."
Why can't people tell the truth?
It is impossible not to lie.
It is February and not lying is impossible.

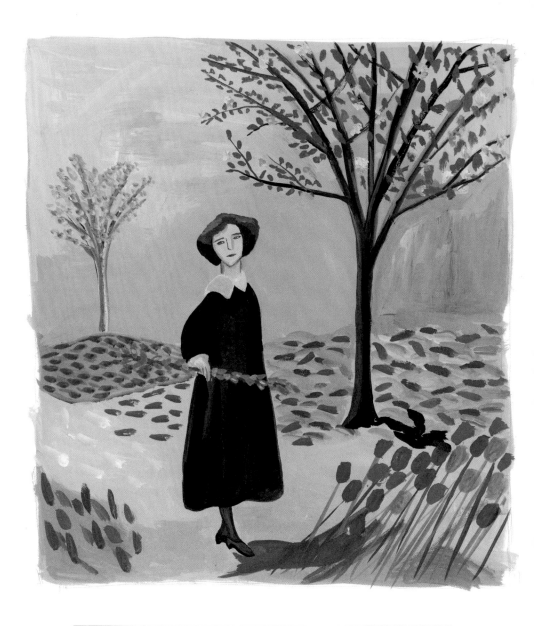

The woman stood in front of the tree before
she went mad. She wrote a book and then she went
mad. How do you go mad?
 How do you not go mad?

The woman is very ill. Her little dog never leaves her side.

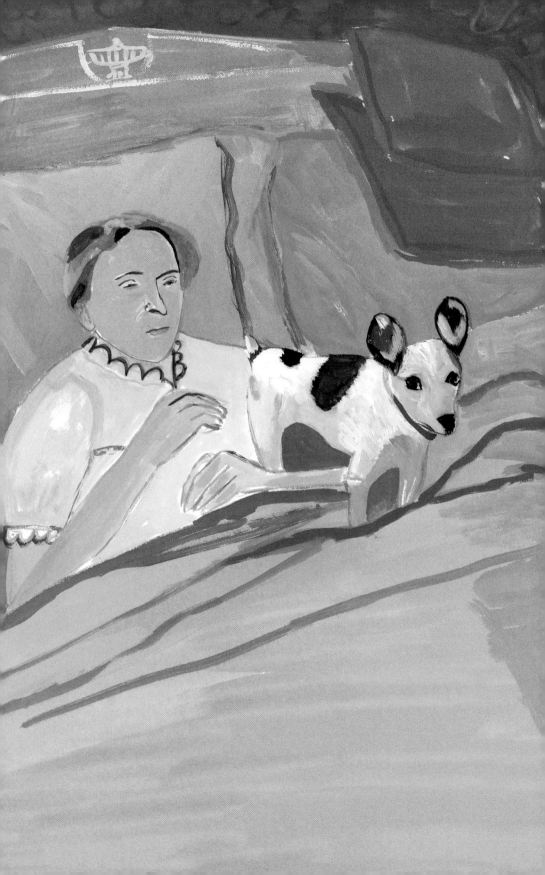

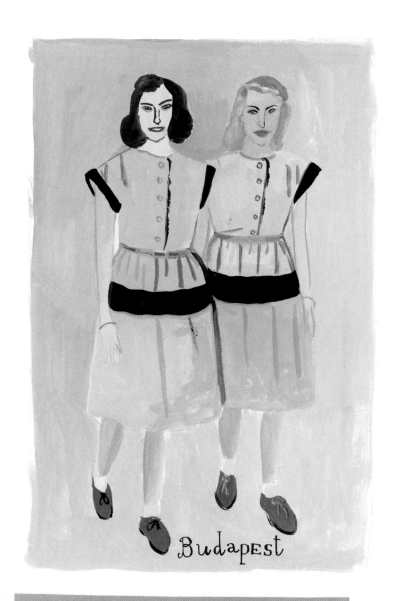

Budapest

These twin sisters, walking down the street in
Budapest, are cousins of the ill woman.
There are black stripes on their sleeves.
One sister is Marianne. She will marry George
and become my mother-in-law.

The other sister is named Dolly. She will marry
Mr. Tiger and become Dolly Tiger.
Things have not always gone smoothly, but
that is life and all is forgiven. I think.

The sisters will never meet this man, but I have,
and he has black stripes on the sleeves of his
magnificent hand-stitched robe. He is a monk.
On his card it says INNER PEACE CENTER.

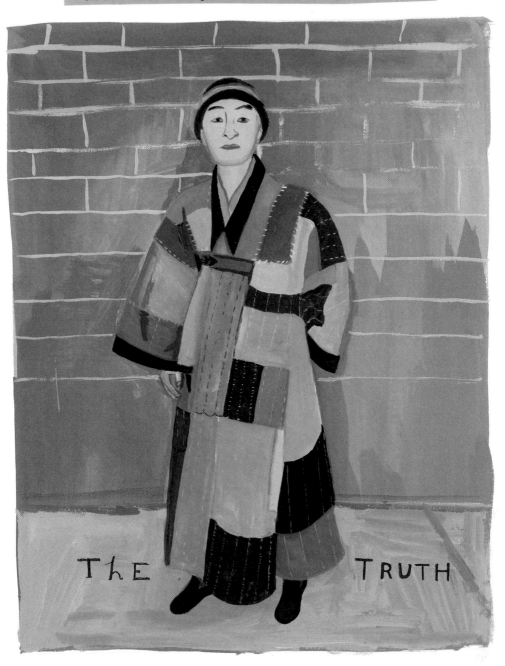

THE TRUTH

I will go there in February for a tea ceremony.
Does he actually know more than I do about inner peace?
If he met my relatives, would he have a nervous breakdown?
What about his relatives? Do they drive him nuts?
 The truth is everybody gets on everybody's nerves.

My parents had a tea party in 1963, for unknown reasons.
There was ZERO inner peace at this party.

My parents were barely speaking.

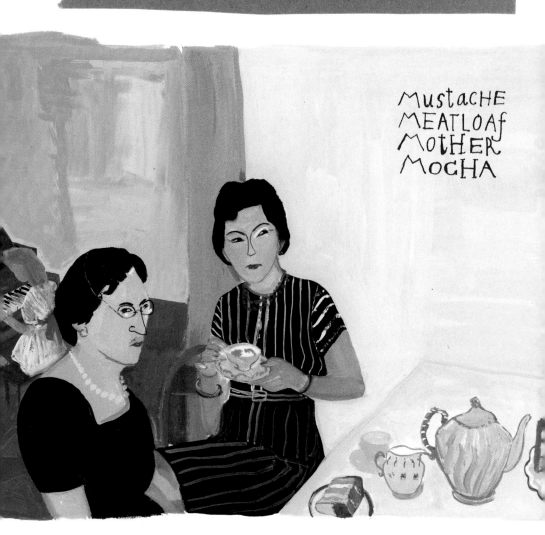

MustacHE
MEATLOAf
MotHER
MocHA

The woman on the left had a very prickly mustache.
She wore a pince-nez with a crazy string thing
going around her head.
She was a dentist and served meatloaf sprinkled
with colored cookie crumbs.

The woman on the right, for all her tea daintiness,
was spiteful and full of malicious gossip. That is
something everybody does once in a while, but with her
it was a full-time job.
She hurt people's feelings right and left.
She hurt my mother's feelings.
She had not an iota of remorse.

The heart breaks.
Someone does or does not go mad.
It is February.
And all is forgiven.

And the cake? I believe it was a Mocha Cream Cake from
Mother's Bakery on Johnson Avenue in Riverdale, N.Y.

MARCH 7, 2007

•

Thickening clouds will
yield light snow.

PART 1.

DREAMS, FREUD'S MISTRESS, WITTGENSTEIN'S RADIATOR

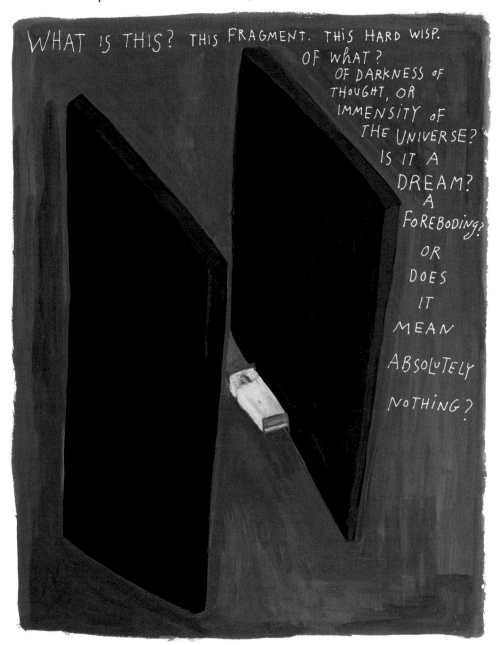

WHAT IS THIS? THIS FRAGMENT. THIS HARD WISP. OF WHAT? OF DARKNESS OF THOUGHT, OR IMMENSITY OF THE UNIVERSE? IS IT A DREAM? A FOREBODING? OR DOES IT MEAN ABSOLUTELY NOTHING?

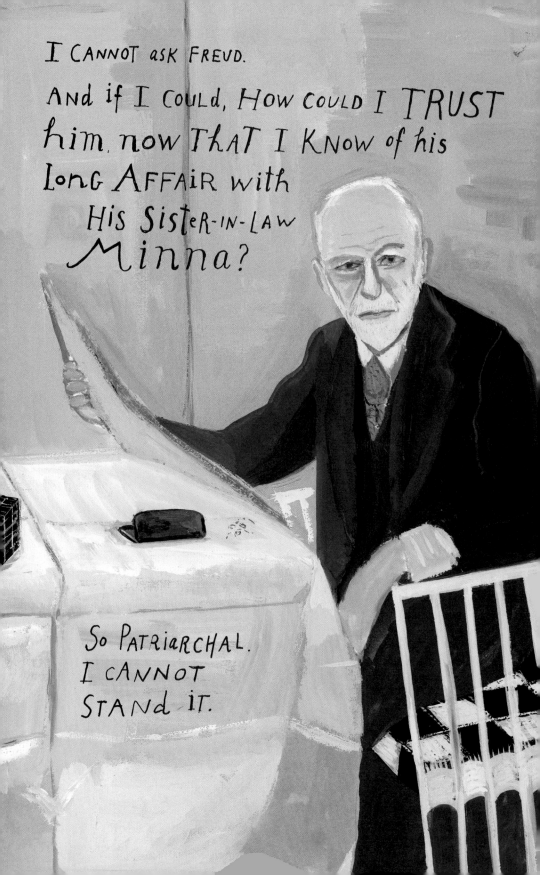

BUT hE WAS A GENIUS (WAS HE?) WHO BELieVED
That WHAT WE SAY Means SomeThing.
AND MUST BE SPOKEN.

RIGHt aRound THE CORNER FROM
FREUD, LIVES The SEXY wiTTgENSTEIN,
who is ThinKiNG that ULTiMATeLY
whaT we SAY Means NOTHiNg.
CONFUSiNG, YET aLLURiNg. SomeHow
THERE MAY BE MORE HUMOR THeRE.
BUT ThREE OF his FOUR BROThERS
KiLLED THemSELVES and THAT iS
TRAGIC and FANTASTICALLY DISTRESSING.

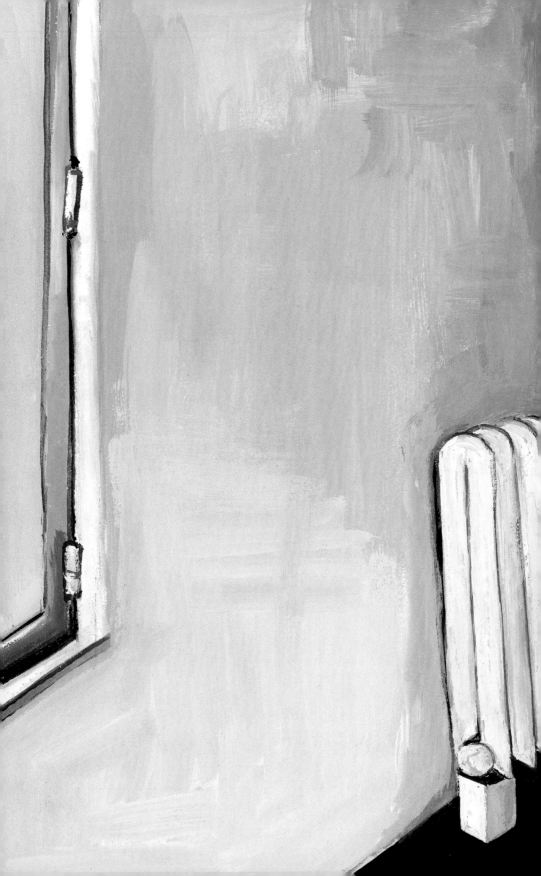

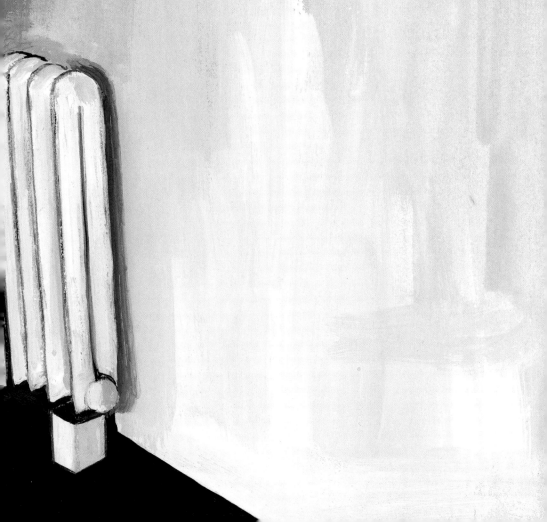

WITTGENSTEIN DESIGNED A HOUSE FOR HIS SISTER,
EVERY INCH AND EVERY ITEM. HERE IS THE
RADIATOR. TO SAY THAT HE FOUND GOD IN
THE DETAILS WOULD BE AN UNDERSTATEMENT.
BUT HOW WOULD HE DEFINE GOD?

HE MAY HAVE BEEN ECCENTRIC, BUT HE WAS NOT ACTUALLY A HERMIT AND WOULD NOT HAVE BEEN INCLUDED IN THIS CHARMING BOOK, EVEN THOUGH HE SPENT A GOOD AMOUNT OF TIME IN ENGLAND.

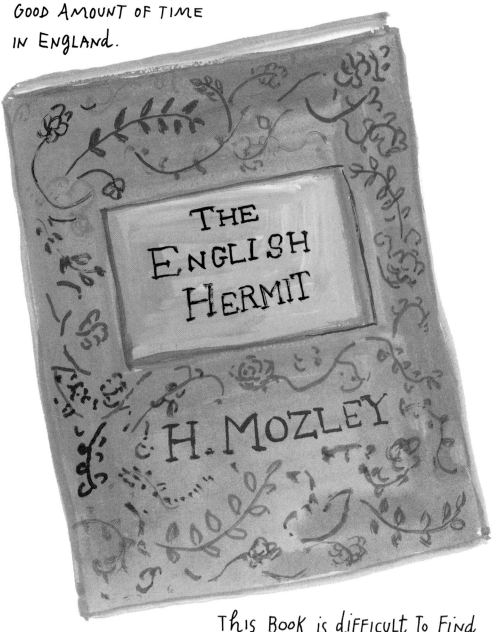

THE ENGLISH HERMIT

H. MOZLEY

THIS BOOK IS DIFFICULT TO FIND, BUT I WILL BUY ANOTHER BOOK, "RICHARD ROLLE, HERMIT OF HAMPOLE."

PART 2.
THE WONDERFUL PHILOSOPHER

THE WONDERFUL PHILOSOPHER
MET ME FOR TEA.

HE ATE A BEAUTIFUL CREPE
WITH WHIPPED CREAM.

HE WAS SO JOYOUS AND GROUNDED
AT THE SAME TIME,
I WAS JOYOUS.

HE LEFT ME WALKING ON AIR.
I MADE A DECISION.
NO MORE THINKING.
YES, WALKING ON AIR.

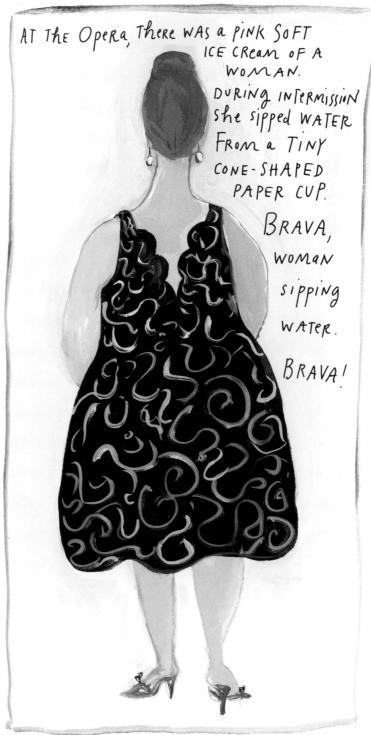

AT THE OPERA, THERE WAS A PINK SOFT ICE CREAM OF A WOMAN. DURING INTERMISSION she sipped WATER FROM a TINY CONE-SHAPED PAPER CUP.

BRAVA, WOMAN sipping WATER.

BRAVA!

THE OPERA WAS "EUGENE ONEGIN," BY
TCHAIKOVSKY, FROM THE STORY BY PUSHKIN.
THE CHARACTERS had So MANY TROUBLES,
DON'T ASK.
IN the OPERA, ONEGIN KILLS his
good FRIEND, the POET LENSKI IN
A COMPLETELY IDIOTIC DUEL OF HONOR.

IN Real LIFE, PUSHKIN WAS married To
NATALYA GONCHAROVA. SHE WAS
ALWAYS DEMANDING SUMPTUOUS
PARURES.

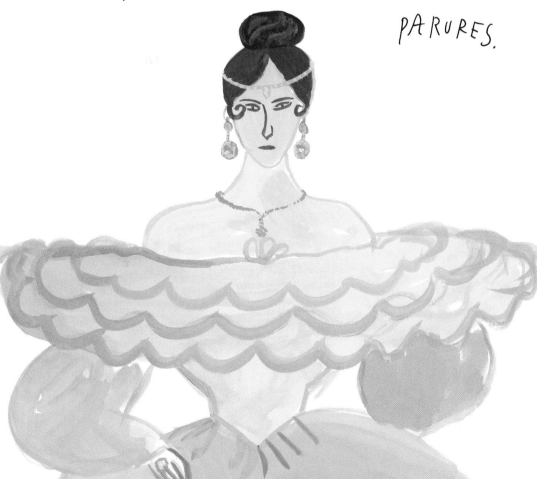

IN THOSE DAYS A SUMPTUOUS PARURE COULD INCLUDE
A TERRIFIC KOKOSHNIK
WORN TO FANCY DRESS BALLS.

BUT NaTalya WAS CONDUCTING a CLANDESTINE affair
WITH BARON D'ANTHÈS. PUSHKIN CHALLENGED HIM
TO A DUEL and guess WHAT GUESS WHAT? PUSHKIN DIED!
CaN You BLAME THE SERFS? No. BUT did Things Go FROM
BAD TO WORSE? YES and NO.

PART 4.
Richard Devereaux, Walter Benjamin, Helen Levitt,
Saul Steinberg, Isaiah Berlin and Alexander Herzen

Richard Devereaux recommends books of great beauty.
He tells me to read "Berlin Childhood around 1900,"
by Walter Benjamin.

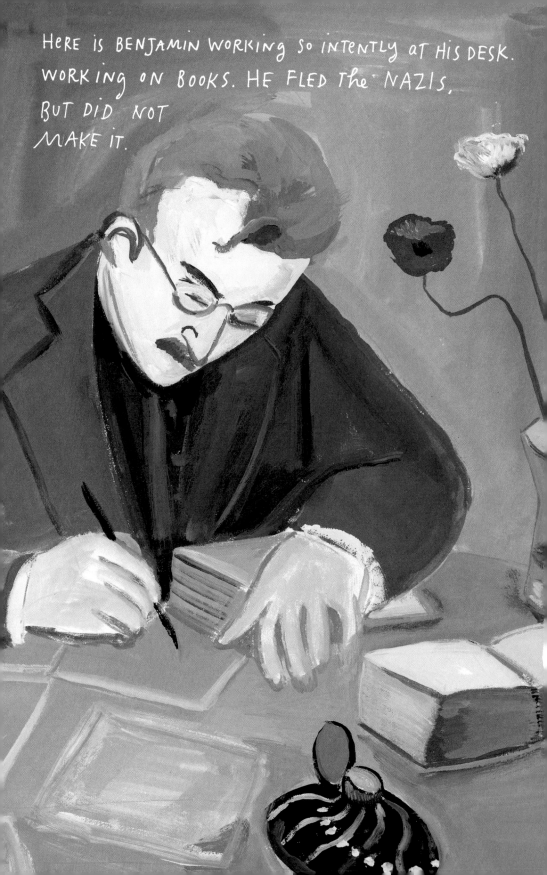

RICHARD TAKES ME TO VISIT THE PHOTOGRAPHER HELEN LEVITT. She HAS TAKEN SO MANY PHOTOS OF LIFE IN THE CITY.

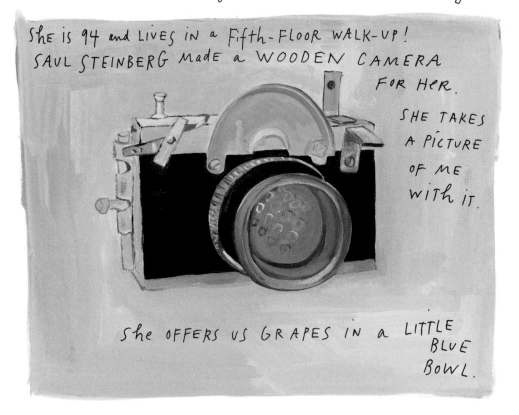

She is 94 and LIVES IN a Fifth-FLOOR WALK-UP!
SAUL STEINBERG MaDE a WOODEN CAMERA FOR HER.

SHE TAKES A PICTURE OF ME WITH IT.

She OFFERS US GRAPES IN a LITTLE BLUE BOWL.

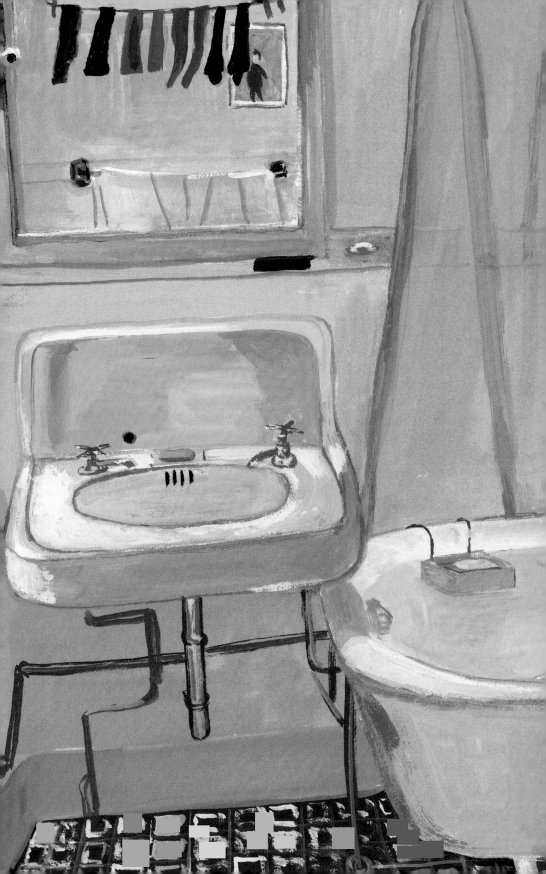

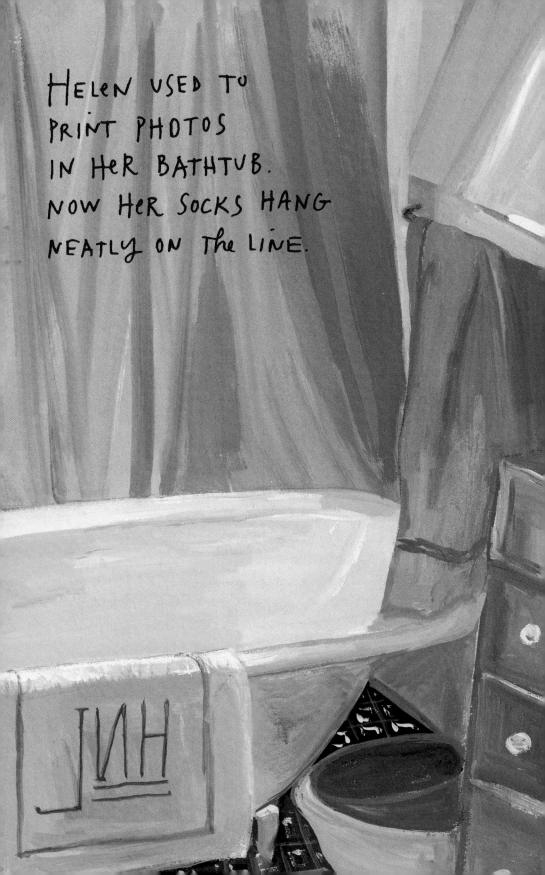

HeLeN USED TO
PRINT PHOTOS
IN HeR BATHTUB.
NOW HeR SOCKS HANG
NEATLY ON THE LINE.

SAUL STEINBERG MADE A JEWEL OF A
LITTLE RED NOTEBOOK FOR ISAIAH BERLIN.
BERLIN WROTE A BOOK
CALLED

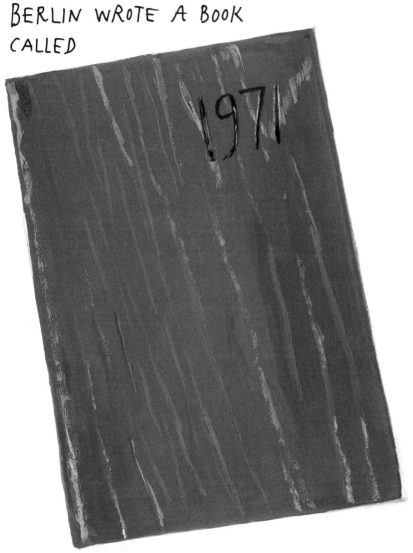

"RUSSIAN THINKERS" that INCLUDED a
Section ON ALEXANDER HERZEN,
ONE OF THE EARLY ARCHITECTS OF
THE RUSSIAN REVOLUTION HERZEN HAD
TROUBLES TOO. WE ALL DO, BUT WE DON'T
START REVOLUTIONS. BUT MAYBE WE SHOULD.

PART 5.
BOBBY PINS

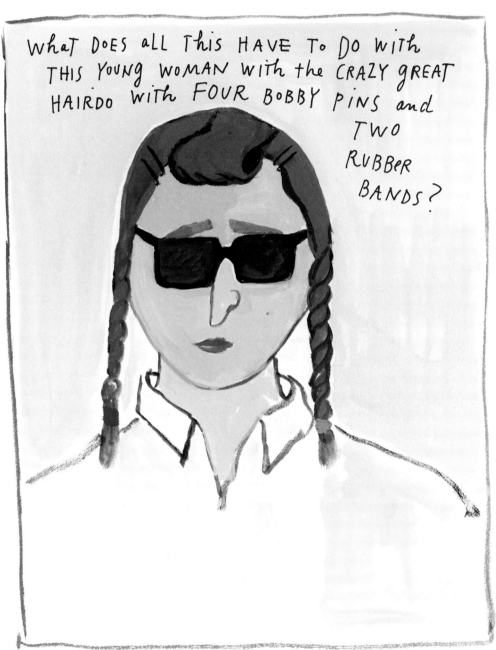

WHAT DOES ALL THIS HAVE TO DO WITH THIS YOUNG WOMAN WITH THE CRAZY GREAT HAIRDO WITH FOUR BOBBY PINS and TWO RUBBER BANDS?

OR The
DAZZLING
WOMAN
with the
THREE
EXTRA LARgE
BOBBY PINS —

I did NOT
SEE The
OThER SIDE —
So peRHAPS
ThERE WERE
SIX IN
TOTAL.
BUT I
COULD BE
WRONG.

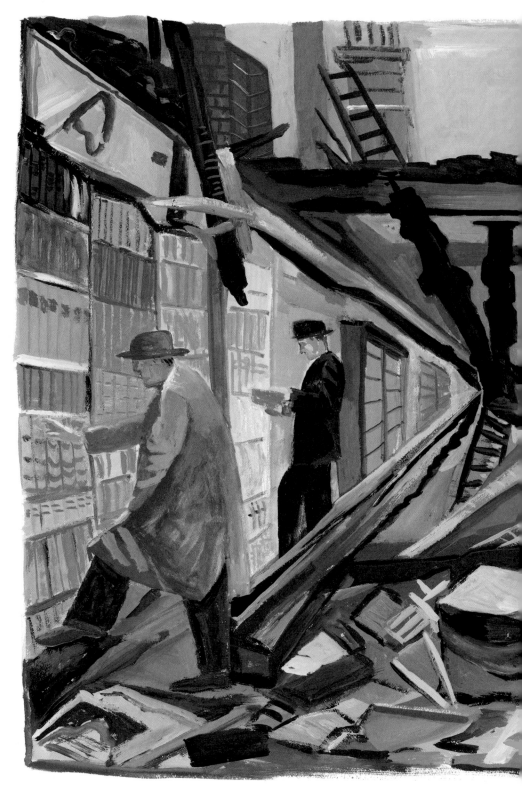

This is a PAINTING OF A PHOTO TAKEN IN LONDON IN 1940. It is a LIBRARY that WAS BOMBED IN the BLITZ.

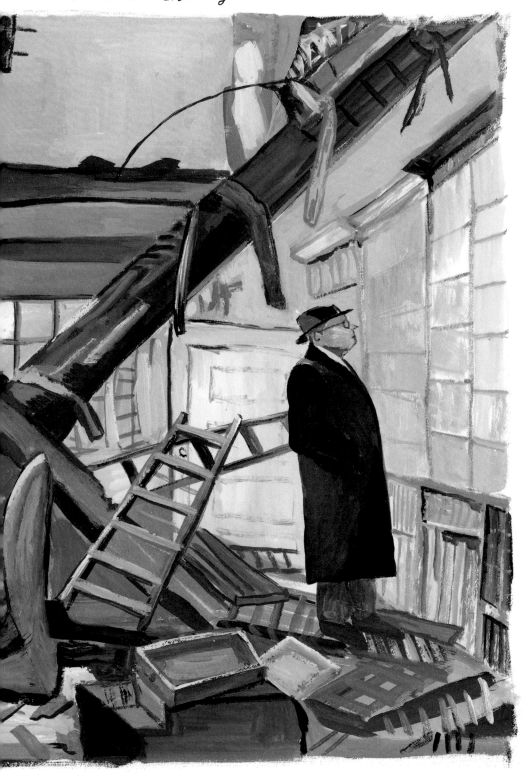

AND THEN THE ALL-CLEAR SOUNDED.
And people RETURNED, hope UNDIMINISHED.
They RETURNED, so elegant and purposeful
to the BOOKS.
What DOES this HAVE TO DO WITH BOBBY PINS
and RADIATORS and KOKOSHNIKS?
ONE thing LEADS TO ANOTHER.

FLOWERS lead to BOOKS, which LEAD TO
THINKING and NOT THINKING and THEN
MORE FLOWERS and MUSIC, MUSIC. THEN
MANY MORE FLOWERS and MANY MORE BOOKS.

SPRING IS
IN THE AIR.
Don't you think?

APRIL 4, 2007

•

Spring showers and
fresh breezes arrive.

Part 1. Precarious

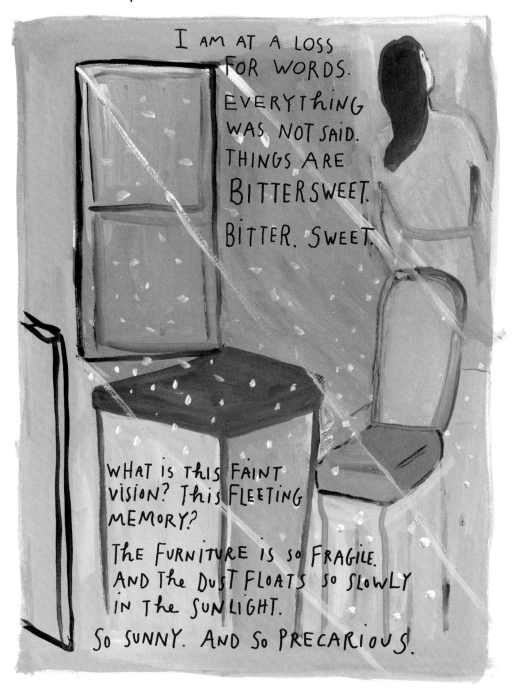

I am at a loss for words. Everything was not said. Things are BITTERSWEET. Bitter. Sweet.

What is this faint vision? This fleeting memory?

The furniture is so fragile. And the dust floats so slowly in the sunlight.

So sunny. And so precarious.

PaRT 3. Pina Bausch

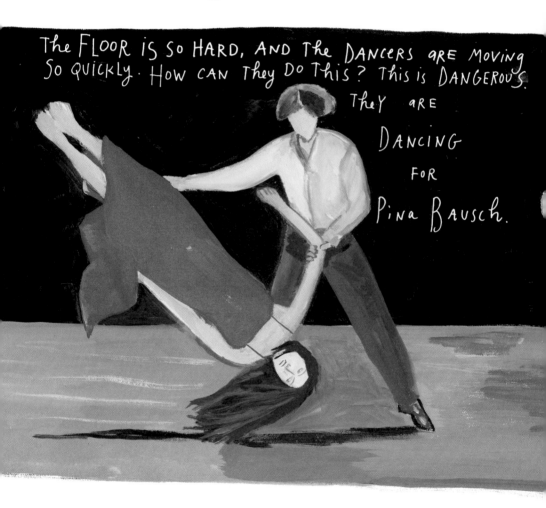

The FLOOR IS SO HARD, AND The DANCERS aRE MoViNG So QUICKLY. HoW CAN They Do This? This is DANGEROUS. TheY aRE

DANCING

FoR

Pina Bausch.

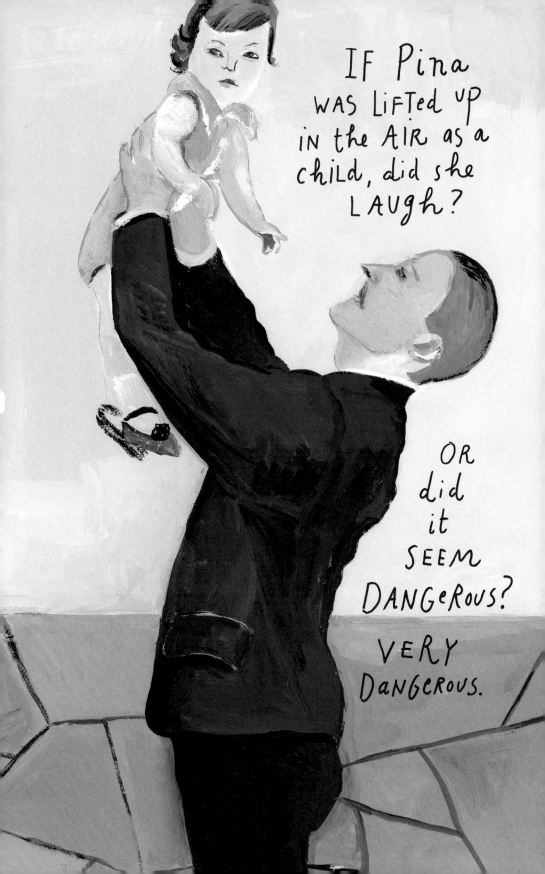

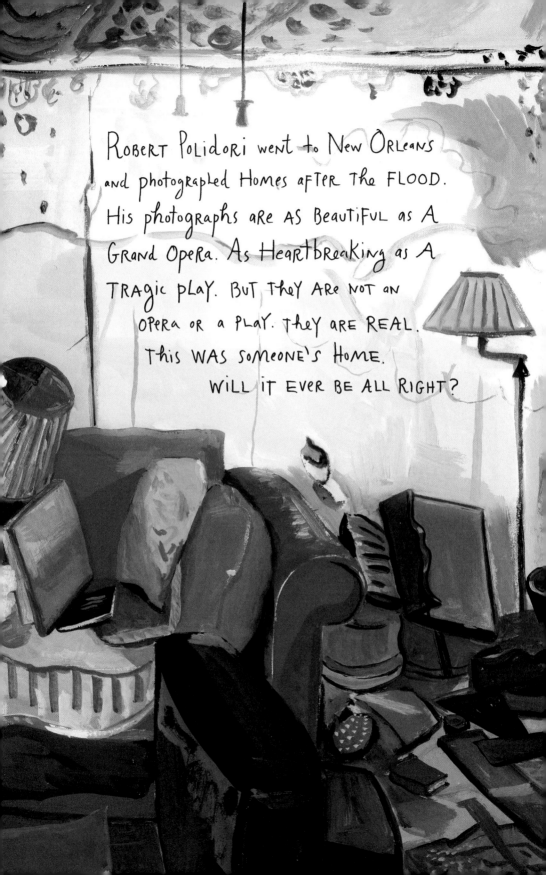

ROBERT POLIDORI went to New ORLeans and photographed Homes afTeR The FLOOD. His photographs aRe AS BeaUTiFUL as A GRand OpeRa. As HeaRtbReaKing as A TRAGic pLAY. BUT ThEY ARe NoT an OPeRa oR a PLAY. ThEY aRE REAL. This WAS someone's HomE.
 WILL iT EVER BE ALL RIGHT?

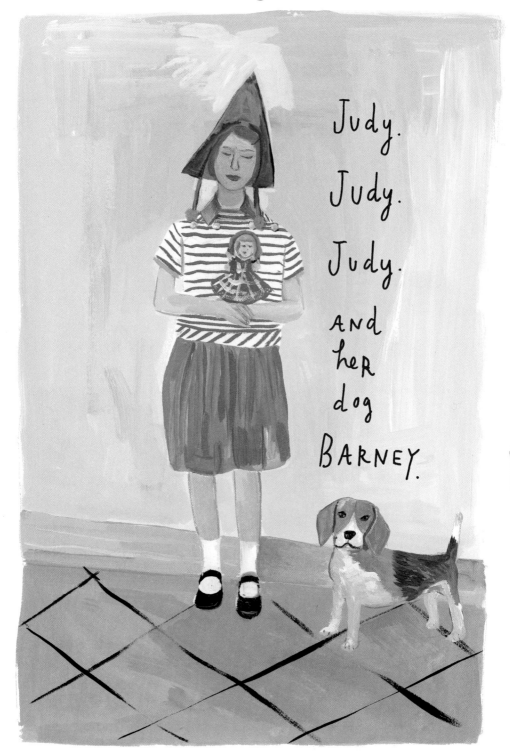

Judy.

Judy.

Judy.

and her dog BARNEY.

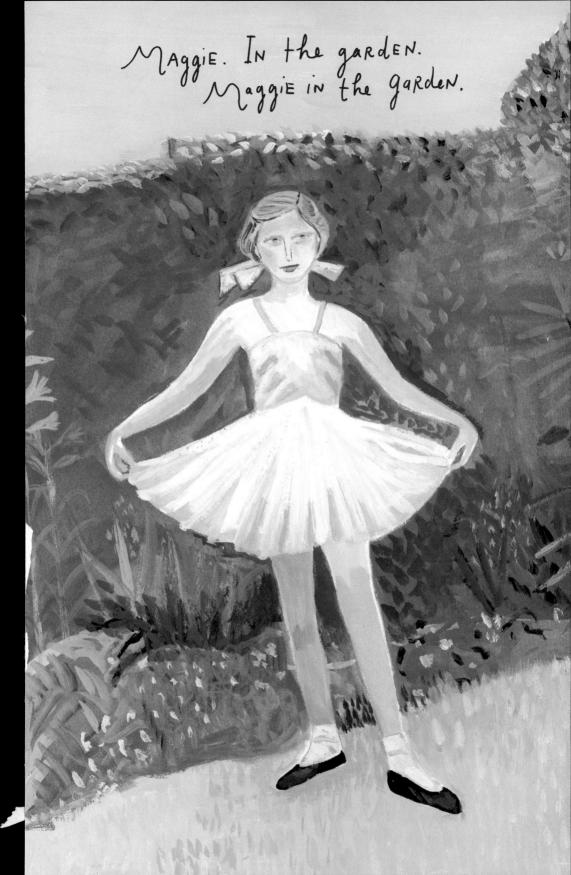

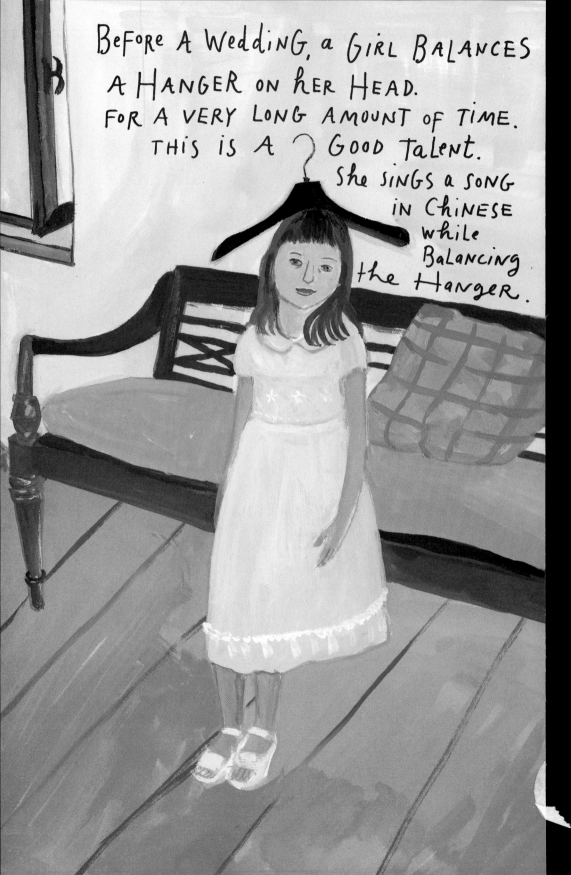

Little Wolfgang Amadeus and his Sister Nannerl perform in the Palace.

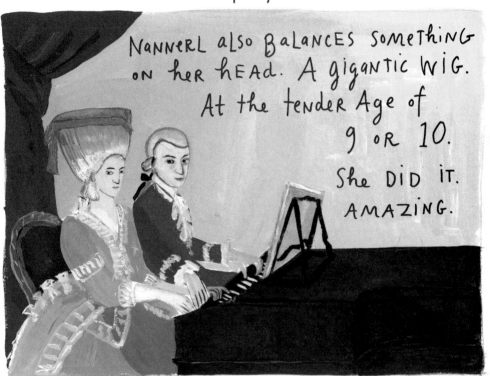

Nannerl also balances something on her head. A gigantic wig. At the tender age of 9 or 10. She did it. Amazing.

HeRe is a
paRTy By the
SeiNe that
CartieR-BResson
photogRaphed.
With childReN
and tutus and
enchanted
Light and
time stopped.

I want that moment to Be My Life. My complete Life. With some visits to the Stationery store. And while we are there a visit to JOE JUNIOR Coffee SHOP Next door.

At JOE JUNIOR, don't think. Just order A

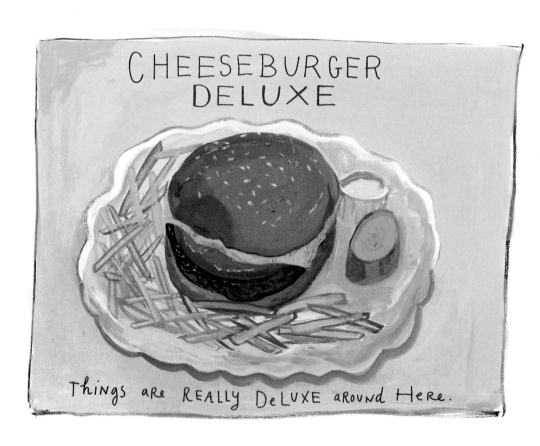

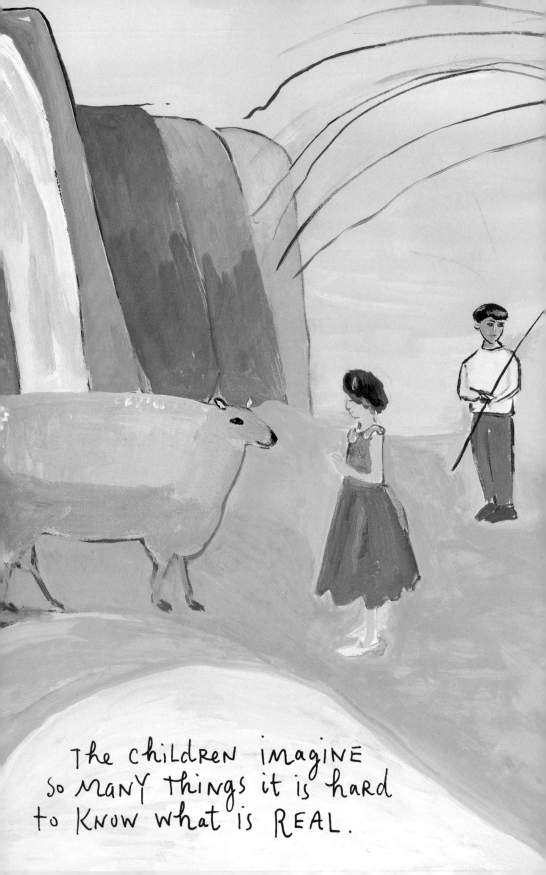

the children imagine
so many things it is hard
to know what is REAL.

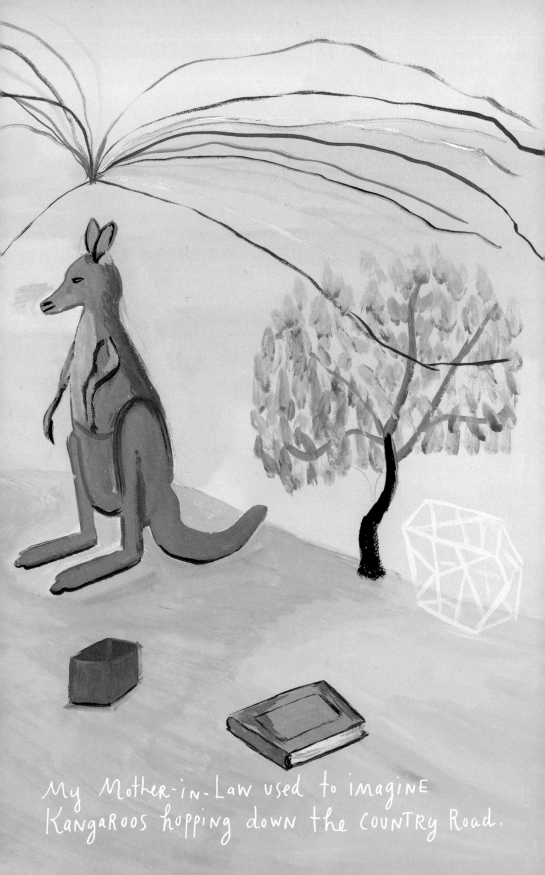

My Mother-in-Law used to imagine Kangaroos hopping down the COUNTRY Road.

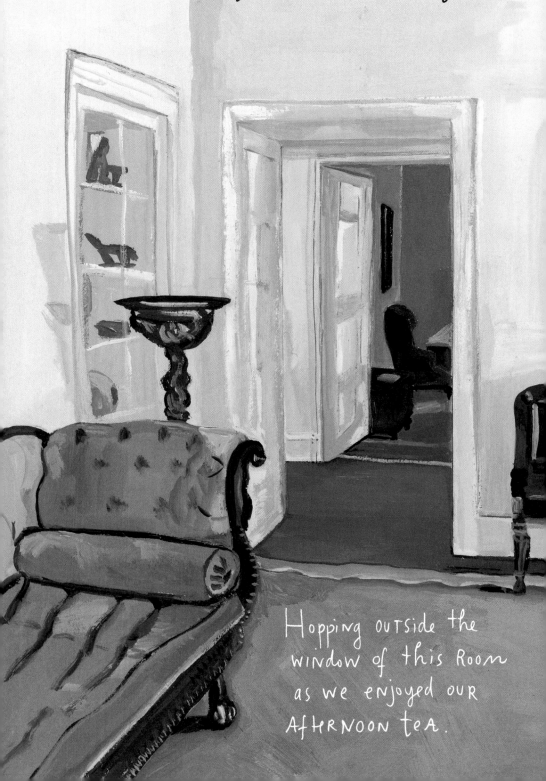

Maybe they were actually there.

Hopping outside the window of this room as we enjoyed our afternoon tea.

Part 6. JULIE and VICKIE

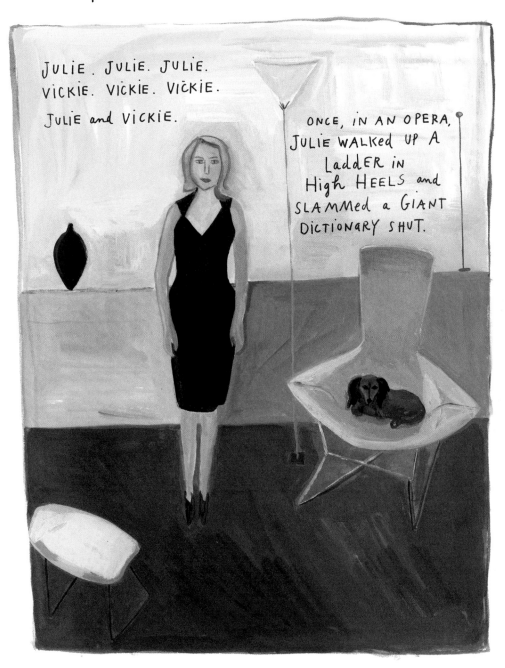

JULIE. JULIE. JULIE.
VICKIE. VICKIE. VICKIE.
JULIE and VICKIE.

ONCE, IN AN OPERA,
JULIE WALKED UP A
LaddER IN
High HEELS and
SLAMMED a GIANT
DICTIONARY SHUT.

Part 7. THE DELIGHTFUL PARTY

I WOULD LOVE YOU TO COME TO MY PARTY.
It WILL BE ON a Sunday AFTERNOON.
LET'S AVOID a NIGHTTIME PARTY. WHO CAN
Stand the NIGHT? NOT I.

WE will Start with a
SMORGASBORD.

NO.

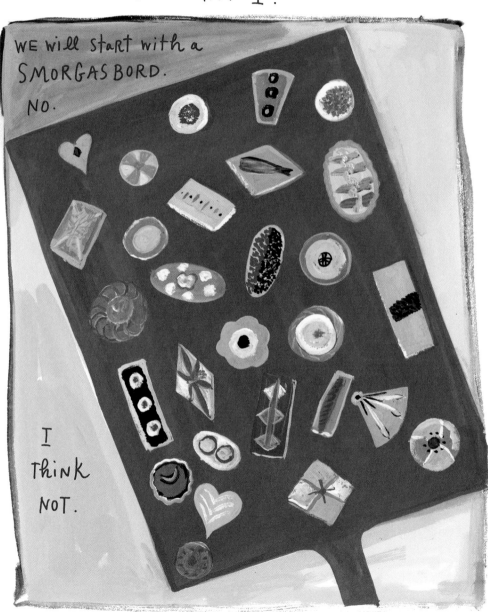

I
THINK
NOT.

We will begin with
Bouchées à la Reine

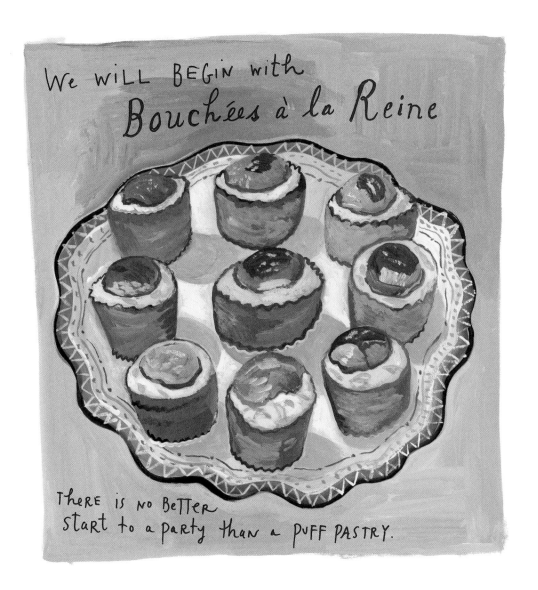

There is no better start to a party than a puff pastry.

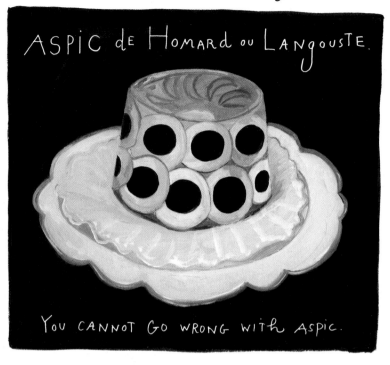

ASPIC de Homard ou Langouste.

You CANNOT GO WRONG WITH ASPIC.

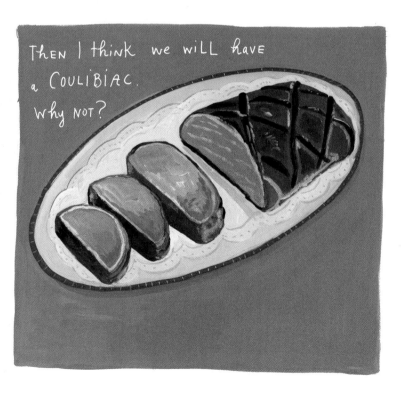

Then I think we will have a COULIBIAC. Why NOT?

And finally, for Dessert

Bombe Comtesse Marie.

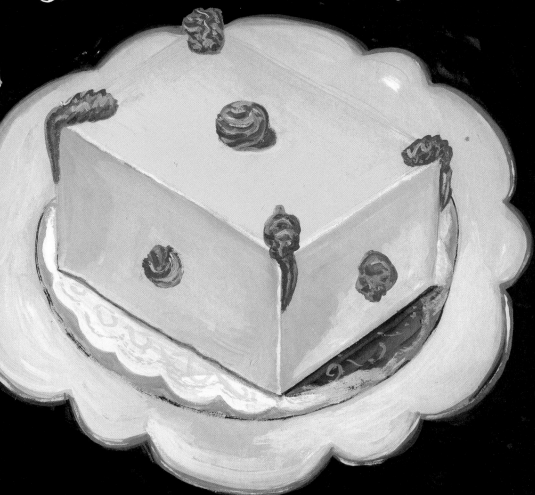

It will be absolutely
Delightful. Nothing will go WRONG. BUT

if something DOES go WRONG,
here is my advice.

DURING WORLd WAR II peopLe Looked
at this PoSTeR. NOT A BAd Thing to
RemembeR. UNdeR ANY CIRCUMSTaNCES.

KEEP
CALM
AND
CARRY
ON

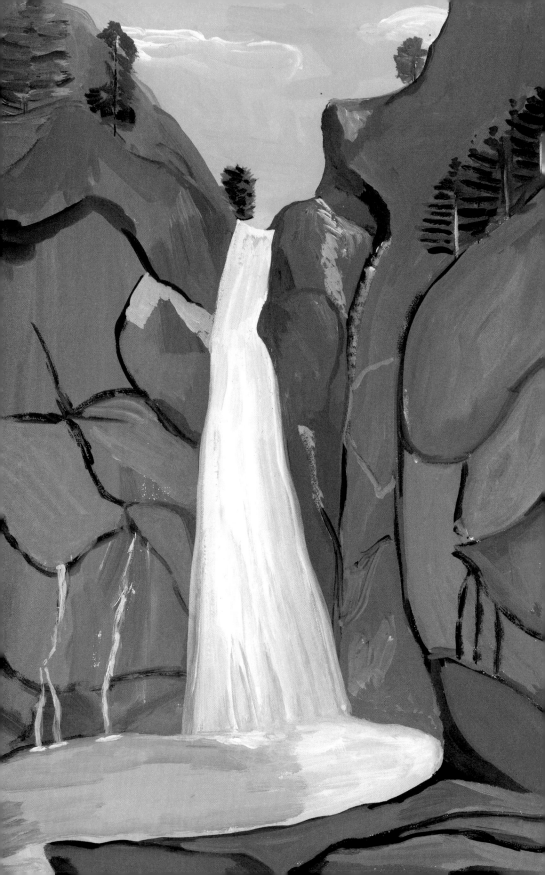

INDeed. INDeed.

So LoNG, dear FRIeNDS.
UNTiL we MEeT AGAiN.

Index

Book fly leaf

Honey Cake recipe

Take a Bundt pan.
Smear with butter and fine
 coat of Bread crumbs.

Ingredients
 4 Jumbo or large Eggs
 3/4 Cup Sugar
 1/2 Cup Corn Oil
 3/4 Cup Dark Honey
 3 Cups Flour
 1 Level tablespoon Baking Powder
 1/2 Teaspoon Baking Soda dissolved in
 tablespoon of water
 1 1/2 cups Very Strong 3 Bags) Tea
 Do This FIRST so tea can cool down

 3 Teaspoons each of:
 Ground Cloves, Cinnamon,
 Ginger, Cocoa
 (adjust amounts to taste)

With Medium Speed Mixer
Mix Sugar and Eggs - add one
 egg at a time until Blended
Slowly pour in Oil. Add Honey.
Mix Baking Powder into Flour.
Slowly Alternate some Flour and
 some tea into Batter.
Mix Spices together
 and pour into batter.
Add Baking Soda. Gently Mix
Bake at 350° for
 Approx 45 minutes.

"...For it was always
on Sunday afternoons
that Babett and Bina
consumed either the
stale applecake or the
stale guglhupf with
their Sunday
afternoon coffee..."
—*Vertigo*,
W.G. Sebald

Hotel Celeste postcards

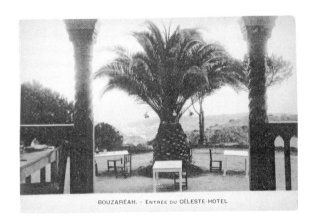

BOUZARÉAH. - Entrée du CÉLESTE-HOTEL

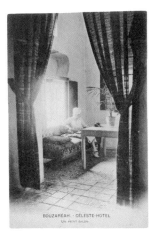

BOUZARÉAH. - CÉLESTE-HOTEL
Un petit salon

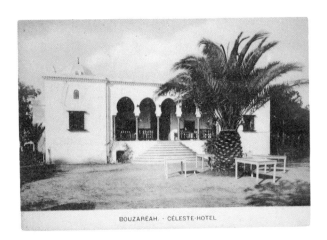

BOUZARÉAH. - CÉLESTE-HOTEL

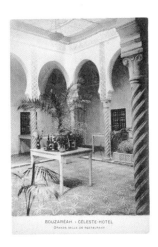

BOUZARÉAH. - CÉLESTE-HOTEL
Grande salle de restaurant

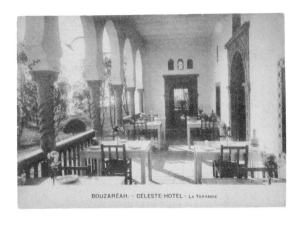

BOUZARÉAH. - CÉLESTE-HOTEL - La Terrasse

Names in Part I of the Idiot
by Fyodor Dostoevsky

Mr. Pavlishtchev
Madame Epanchin
General Epanchin
Nikolay Andreyevitch Pavlishtchev
Prince Lyov Nikolayevitch Myshkin
Parfyon Rogozhin
Semyon Parfenovitch Rogozhin
Vassily Vassilitch Konyov
Semyon Semyonovitch
Nastasya Filippovna Barashkov
Lebedyev
Barashkov
Afanasy Ivanovitch Totsky
Alexander Lihatchov
Armance
Coralie
Princess pAtsky
Lihatchov
Salyozhev
Andreyev
Seryozha Protushin
Ivan Fyodorovitch Epanchin
Alexandra Adelaida
Aglaia
Gavril Ardalionovitch Ivolgin
Dr. Schneider
Lizaveta Prokofyevna
Abbot Pafnuty
Pogodin
Nina Alexandrovna
Ferdyshtchenko

Varvara Ardalionovna
Ivan Petrovitch Ptitsyn
Kolpakov
Ardalion Alexandrovitch
Princess Byelokonsky
Biskup
Dr. Pirogov
General Sokolovitch
Kulakov
Alexandra Mihailovna
Madame Mihailovna
Madame Terentyev
Marfa Borissovna
Mytovtsov
Ippolit
Kinder
Trepalov
Darya Alexeyevna
Marya Semyonovna
Nikifor
Platon Ordyntsev
Anfisa Alexeyevna
Petya Vorhovsky
Countess Sotsky
Sofya Bezpalov
Katerina Alexandrovna
Madame Zubkov
Sevely
Zalyozhev

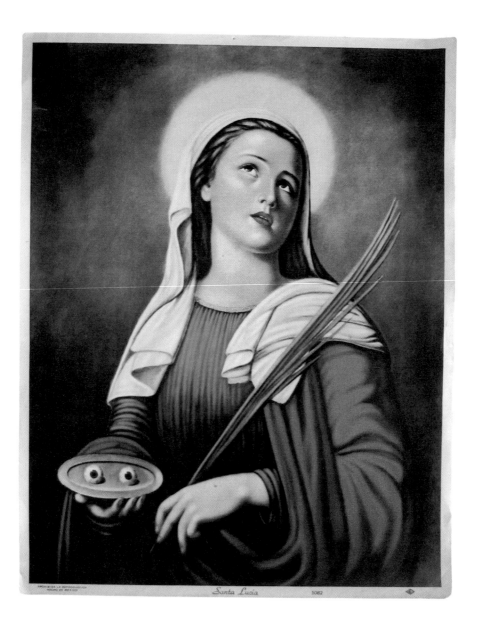

Santa Lucia

S. LUCIA V. M.

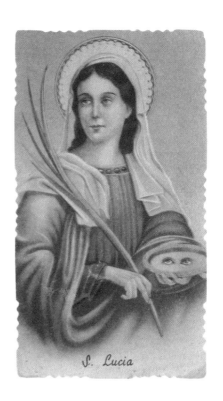

S. Lucia

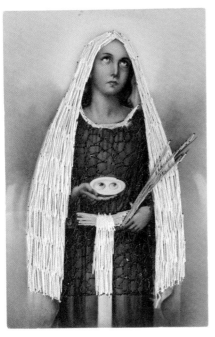

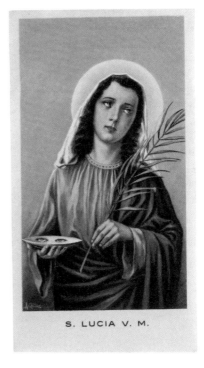

S. LUCIA V. M.

Numbers

547

COAT ROOM CHECK
If any loss claim
before going out.

Not responsible for contents
of garments or anything
left overnight

Welcome to Sammy Noodle Soup

143

1/27/2007 3:03:42 pm

PASSED
総新合格 **76**

18

1579212

**YOUR
NUMBER**

12

WHEN CALLED
IT'S YOUR TURN
FOR SERVICE

GLOBE TICKET CO.
PRINTED IN U.S.A.

PRINTED IN U.S.A.
GLOBE TICKET CO.

FOR SERVICE
IT'S YOUR TURN
WHEN CALLED

30

**NUMBER
YOUR**

1571530

42 42

INSPECTED BY
11

The Modern

3

112

CLAIM CHECK
IN CASE OF ANY LOSS,
CLAIM BEFORE LEAVING
Not Responsible for
Contents of Garments or
anything left overnight

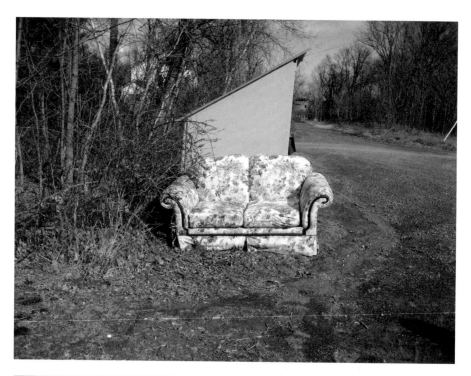

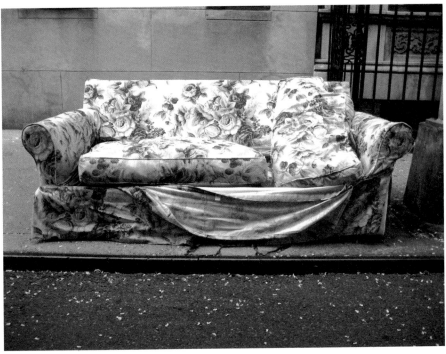

Packets

Shoes of composer Nico Muhly

Norman Weiss' Tesseract sketch

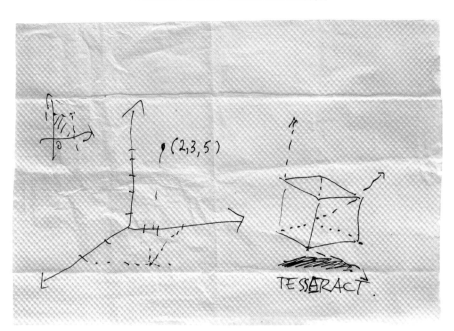

British toothpick

Waterfall postcards

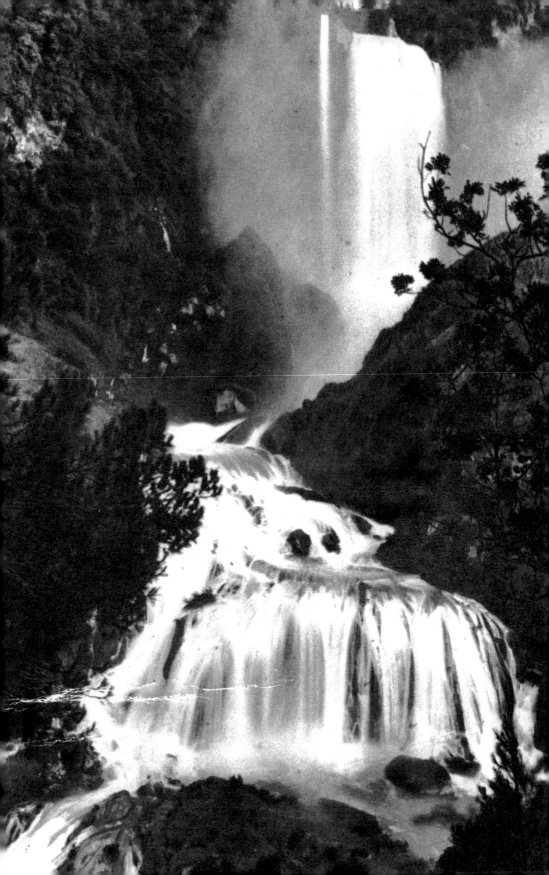

Thank You

If my **parents** did not leave our sandy, shiny home and if my **sister** was not beautiful and did not stand with arms akimbo and if I did not sit under a tree in Henry Hudson Park and did not meet **Judy** who was also beautiful with red hair and if I did not run across the highway and play ping pong and do horribly in math and daydream and if **Eric Etheridge** did not look at me or think of me and bring me into the New York Times building where I have always felt a quiver and if he did not introduce me to the luminous and true **Mary Duenwald** and if **David Shipley** did not feel like thinking or naming a book and if **Brian Rea** had not loved art and only played the violin and if **Sam Weber** lived in Ashtabula instead of here and if **Sasha Koren** had not left crisp snowy mountains to move to this place and if the **New York Times** said get out of here we don't want this column and if **Ann Godoff** did not call me or feel like being an editor who said you do what you feel and if **Charlotte Sheedy** did not call her or me and tell me what is what and if **Meredith Kaffel** was only interested in ornithology and if **Claire Vaccaro** was not gentle and kind and if **Lindsay Whalen** did not organize and dance very well and if **Beena Kamlani** and **Judith Hancock** did not feel like making the heartwarming index and if **Phyliss Whitehouse** had not been so gracious and if **David Lewis** did not feel like accompanying **Kitty Carlisle Hart** so I could melt with pleasure listening to her sing and if **John Willenbecher** had a cold and did not feel like connecting me to **Louise Bourgeois** and if **Jerry Gorovoy** was too busy and if **Richard Devereaux** did not love books and did not bring me to the smart and sharp **Helen Levitt** and if **Elizabeth Beautyman** said go away, do, and if **Haim Gaifman** said please, really just go away, and if **Deb Mcbride** did not wear beautiful pink dresses while working on business and if **Julie Saul** did not have such particular style and if she and **Vicky** had snappily walked right by on tiny feet on dear old 12th street and if **Gina Bianco** did not feel like embroidering and did not wear such a great hat and if it hadn't rained and if **Elisabeth Biondi** was not generous and did not feel like introducing me to **Robert Polidori** and if he was not a stunning photographer who traveled to New Orleans and said sure do the painting, and if **Peter Buchanan-Smith's** people had never left their land with their tartans and he had not become a seeker and inventor and designer and if **Josef Reyes** had decided not to work with Peter Buchanan-Smith and just fly to India and collect figurines and if the beloved **girl and boy** were not born and did not fill the world and if there were not other people and other and other and if **Rick** was not a light, a pure light, all would be lost, lost I tell you and I could not have done a thing and there would have been no ardor to muster, no life at all.

JUNE 27, 2007